IMAGES
of America

AUSTIN'S TRAVIS HEIGHTS
NEIGHBORHOOD

ON THE COVER: The original Night Hawk restaurant faces South Congress Avenue at the intersection with Riverside Drive. Opened in 1932, it has been one of Austin's most famous and enduring restaurants. Harry Akin opened this restaurant where once there had been an abandoned fruit stand at 336 South Congress Avenue. The Night Hawk expanded and opened other locations in Austin. By 2018, however, most of them have closed except for the Frisco Grill and a supermarket line of frozen foods continues. The original South Congress Avenue restaurant closed in 1985. (PICA 26611.)

IMAGES
of America

AUSTIN'S TRAVIS HEIGHTS
NEIGHBORHOOD

Lori Duran

ARCADIA
PUBLISHING

Published by Arcadia Publishing
Charleston, South Carolina

Printed in the United States of America

Library of Congress Control Number: 2018948864

For all general information, please contact Arcadia Publishing:
Telephone 843-853-2070
Fax 843-853-0044
E-mail sales@arcadiapublishing.com
For customer service and orders:
Toll-Free 1-888-313-2665

Visit us on the Internet at www.arcadiapublishing.com

To my family who have passed on their love of history to me

CONTENTS

ACKNOWLEDGMENTS

I offer my sincere thanks and appreciation for the help and support I received while developing this book from my husband, Juan, and my family who assisted me in this effort. A special thank-you goes to Michael Barnes for his kindly support, encouragement, and inspiration. I am grateful to Michael Miller and the staff of the Austin History Center, who provided me with expert guidance and assistance. The Austin History Center has been the central historical research repository used for this book. Unless noted otherwise, the images appear courtesy of the Austin History Center (AHC). The image citations refer to the AHC collection that contains the image. Some come from the General Collection and are identified as PICA, PICB, or PICH, or begin with "AF." Other important collections used include the Neal Douglass Photography Collection (citations with "ND"), the Dewey Mears Collection (citations with "DM"), the Russell Chalberg Collection of Prints & Negatives (citations begin with "C"), and the Austin American-Statesman Negative Collection (citations begin with "AS"; images used with permission).

I am grateful also to Franna Camenisch at the Texas School for the Deaf for her time, information, and photographs that helped this book come together. I am very appreciative for the tour of the former Terrace Motor Hotel grounds from Debbie Hill Sherwood and Marsha Hill Whitley. Their contributions were both interesting and informative. I appreciate the contributions from Colin Corgan, Allison Supancic, Ruthann Rushing, Weldon Long, Colleen Theriot, Ave Bonar, Robin Grace Soto, John Stewart, Joe Jung, Dwight Flinkerbusch, Rick Patrick, Carol Castlebury, Schlotzsky's Corporation, HEB Corporation, the Austin Motel, South Austin Memories Facebook Group, and Stacia Bannerman at Arcadia Publishing. I also owe thanks to the University of North Texas Libraries, the Portal to Texas History, and the Texas Historical Commission for some of the images used in his book.

INTRODUCTION

The history of the Travis Heights neighborhood and all south Austin begins in the 1830s. The development has been driven by the Colorado River, now known as Lady Bird Lake, and the need for safe and secure methods to cross it. As the population grew, entrepreneurs created various methods of river crossings, such as canoes, ferries, and bridges. Adjacent streets and highways provided the transportation routes that made south Austin residential sections thrive. Early businesses supported the residential streets, and the area grew despite damaging floods during the Depression years. Education was important, and south Austin had some of the earliest schools in Austin. The Travis Heights neighborhood has had an abundance of naturally beautiful green spaces, churches, a public library, and a fire station, all of which added to the appeal of the area. The Twin Oaks Shopping Center and the South Congress Avenue business district provided for the area residents while continually changing with the times.

From the earliest days of south Austin, a stable way to cross the Colorado River and connect to the rest of Austin influenced the development of Travis Heights. The Swisher family set up a ferry in 1852 for a Colorado River crossing at the foot of downtown Austin's Congress Avenue. The Swishers granted the city right-of-way through a portion of their farm south of the river. They also placed their ferry so that travelers to Austin debarked right onto Congress Avenue, the city's main street, where the Swisher tavern and hotel operated. Substantial business and residential growth followed the building of the first permanent bridge across the river about 34 years later. The San Antonio Highway and the Post Road and later the Interregional Highway 35 (IH-35) encouraged further development. The first south Austin businesses were built along the San Antonio highway. That stretch is now known as South Congress Avenue. Some of the oldest businesses were built about a quarter of a mile south of the Colorado River and are still standing today. Businesses built too close to the river would experience intermittent river flooding, and some were washed away. Floods continued to be a difficult problem until the late 1930s. When I-35 was built in the 1950s, on the far eastern edge of the Travis Heights neighborhood, it prompted development alongside its pathway and farther east. The Travis Heights East neighborhood is just beyond the eastern border of Travis Heights. A small portion of it developed before the building of the interstate that seemed to sever the southeastern tip of Austin. Streets such as Summit Drive, Taylor Gaines, and Parker Lane can be seen on some of Austin's oldest maps. But most of the development of Travis Heights East occurred after the building of I-35, which then prompted additional south Austin developments.

Residential areas came about south of the river, partly in response to the availability and the opportunities in the area and partly because of some early shrewd residential real estate investments. Austin has numerous interesting and historical homes in the Travis Heights neighborhood. There are more than what could be contained in this book, so a considered sampling is included here. The original neighborhood developer's names are reflected in the street names and some of the neighborhood landmarks.

Some of the original streets have been altered to reflect the evolving history and the needs of the neighborhood. The Circle (a street) surrounded the section of land where the State House

on Congress luxury apartments are now located. Today, The Circle is slightly less than a half circle. Part of it became the western stretch of Academy Drive, which was renamed after a boy's military academy in the 1920s. Part of the original Riverside Drive also became part of Academy Drive. Though they have changed since initial construction, other early streets that remain today include East Side Drive, Pecan Grove Road, Hillside Avenue, and Ravine Drive. Other original street names have disappeared, such as The Bluff, Cedar Terrace, The Ramble, North Avenue, and Southside Drive. Today's Newning Avenue replaced Cedar Terrace and part of The Ramble and is named after Fairview Park developer Charles A. Newning. Newning's Fairview Park subdivision success was limited, due to river crossings being seen as unreliable or unappealing. Also, the Swisher Addition, including stockyards and liveries, may have limited the appeal for high-end residential development. Newning had provided some large lots, expecting to sell them to the wealthy. In the end, some of those large lots ended up being subdivided into smaller lots. When the Travis Heights neighborhood was opened to customers, it was designed from the start with different sizes of lots from large to small. The neighborhood was very successful and developed quickly compared to Fairview Park, which developed slowly over the years. The Travis Heights residential development was so successful that the entire area from South Congress on the west edge to I-35 on the eastern edge is commonly called Travis Heights, even though the Fairview Park and Swisher Addition areas have their own characteristics.

South Austin has some of the oldest schools in Austin. The very first school in south Austin was the school built for deaf students in 1857. Originally named the Texas School for the Deaf and Dumb, it was located on the south shore countryside that was thought to be a healthy environment for its students. The natural beauty of the rugged riverside bluffs and tree-lined creek beds attracted others as well. In the late 1870s, the Swisher Addition began to develop along where South Congress anchors it. In the late 1880s, farther east, came the Fairview Park development. With the building of these residential areas, the first Fulmore School was constructed in 1886. Fulmore moved farther south in 1911 and is still located there. Fulmore School was supplemented by the building of Travis Heights Elementary in 1939. In 1953, William B. Travis High School was built on Oltorf Street on the eastern and southern edge of Travis Heights. Before that high school was built, south Austin students who wanted to attend high school had to cross the river to attend Austin High School.

The Travis Heights neighborhood is fortunate to have some magnificent green spaces. The cliffside area immediately on the south shore of Lady Bird Lake, east of Blunn Creek and west of I-35, was originally known as Travis Park and is now named the Norwood Metropolitan Park. The Stacy family, along with the City of Austin, created the long, winding Blunn Creek Greenbelt, capped on one end by Big Stacy Park and on the other end by Little Stacy Park. Two small historical parks, the Circle Greenbelt and South Austin Island, add beauty and interest to the area.

The community around Travis Heights also features many long-standing churches that have helped shape this neighborhood. Two of the oldest churches, Congress Avenue Baptist Church and Grace United Methodist Church, celebrated their centennial celebrations years ago but have changed names since. The mid-century-built churches mostly still exist with their original church names and denominations, with few exceptions. Other community features historically have been the Twin Oaks Library and the fire station. The Twin Oaks Library was located for more than 50 years in the Twin Oaks Shopping Center until it finally acquired a permanent structure of its own farther west on South Fifth Street at the site of the former South Austin Post Office. The original fire station was a volunteer outfit located where the famous Continental Club stands today. In 1932, the City of Austin built a dedicated fire station farther south on South Congress Avenue. The fire department had already moved from using volunteers to employing paid professional firefighters.

The Twin Oaks Shopping Center is one of the oldest shopping centers in Austin. From its earliest years beginning in 1953, it was a focal point and shopping destination for suburbanites and their families. Early Travis High School yearbooks have pages of advertisements from the stores that were located there. The shopping center continued to do well until the last 20 years,

when it lost many of the original businesses. In 2016, HEB purchased the Twin Oaks Shopping Center and then some of the locally owned businesses departed, apparently anticipating further changes. But whether HEB purchased it to construct a new grocery store or for other reasons remains to be seen.

The other businesses in the Travis Heights neighborhood have also had great historical impact and influence. The original businesses were mostly farm and ranching related and grocery stores. With the rise of car ownership and motorists came the motels, tourist courts, gas stations, and restaurants. It is remarkable that several of the earliest business structures are still seen today, considering the fast-paced changes that have taken place on South Congress Avenue, the main business corridor of the neighborhood. South Congress declined after Interstate 35 pulled motorists and customers away from the area. But is has rebounded in the last 15 years. New businesses have opened, and old shops have been remodeled—sometimes into trendy boutiques or sometimes into restaurants. Today, the South Congress business district has become popular with residents and a destination for visitors.

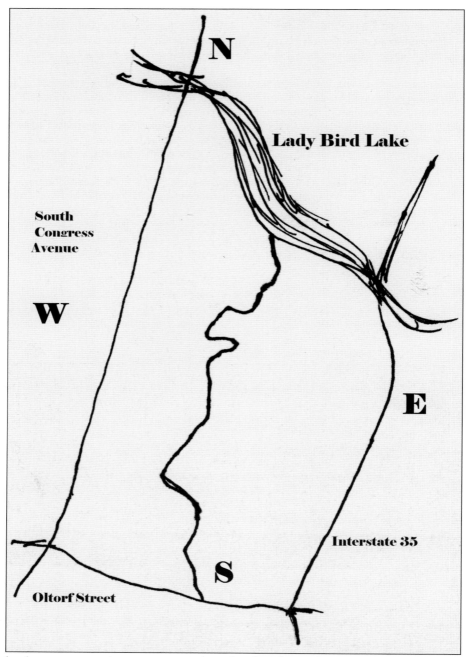

This book encompasses the entire area commonly referred to as the Travis Heights neighborhood, which is bounded by Lady Bird Lake to the north, Interstate 35 to the east, Oltorf Street to the south, and South Congress Avenue on the west side. The neighborhood includes three individual developments: the Swisher Addition, Fairview Park, and Travis Heights. The entire area is divided by Blunn Creek and its greenbelt. Fairview Park and Swisher Addition are on the western side of the creek, and on the eastern side is the Travis Heights subdivision. (Courtesy of Lauren Duran.)

One

EARLY DAYS

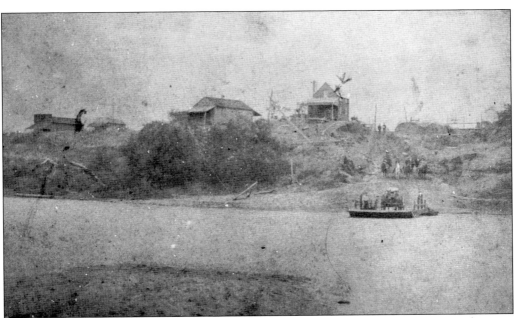

Shown here is a ferryboat on the Colorado River, possibly the Webberville Ferry in the mid-1800s. In 1836, before there were ferries, William Barton offered self-paddling canoe service just west of the entrance to Shoal Creek. By the mid-1840s, ferries across the river had sprung up. John J. Grumbles had a ferry on the west side of town at Shoal Creek, where Barton had kept his canoe. James Gibson Swisher setup a ferry that benefitted travelers coming to Austin from the south as it connected directly with the north side of Congress Avenue. (C00693.)

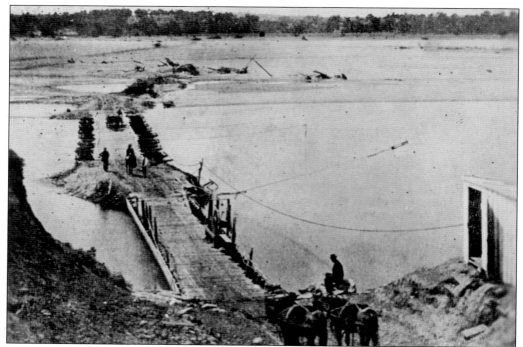

A pontoon bridge in Austin is pictured in the late 1860s. During Austin's earliest years, river crossings were mostly dependent on the water level of the Colorado River. Those in the city of Austin relied on various ferries and a pontoon bridge. During the 1870s, the wooden pontoon bridge washed away with each flood. Before the Colorado River dams and water level control were completed with Longhorn Dam in 1960, the river sometimes dried up enough that people could cross the riverbed on foot. In an interview at the Austin History Center in 2017, Fred Bednarski said that he had walked all the way from East Monroe Street to the University of Texas during the summertime football team trials. He described himself as a real walk-on, as he walked across the dried-out riverbed to get there. (C01694.)

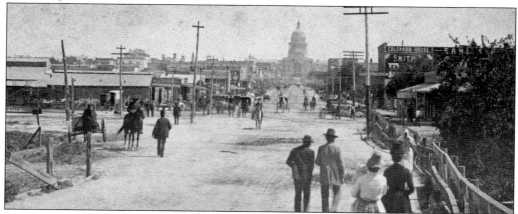

The Congress Avenue Bridge is pictured in the late 1800s. In 1886, Austin finally had a permanent and free (non-toll) bridge spanning the Colorado River. By the early 1900s, bridge traffic had increased to the point that a new bridge was needed. A concrete arch bridge, built in 1910, has withstood devastating floods since, although its approaches have been underwater. (AF-P6150(55)-001.)

The south side of the Colorado River is pictured in 1889. The beginnings of south Austin are linked to the opening of the bridge across the Colorado River in 1886. People in south Austin had been country dwellers prior to that permanent bridge. Then came developers, such as Charles A. Newning, who were attracted to the rugged bluffs on the south bank of the Colorado River. Newning created a development he named Fairview because it had a "fair view" of the city from the bluffs. (PICA 20980.)

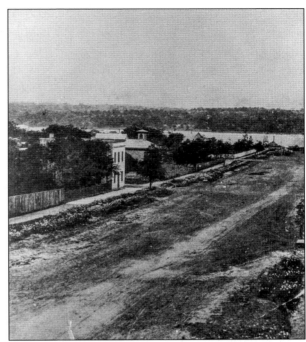

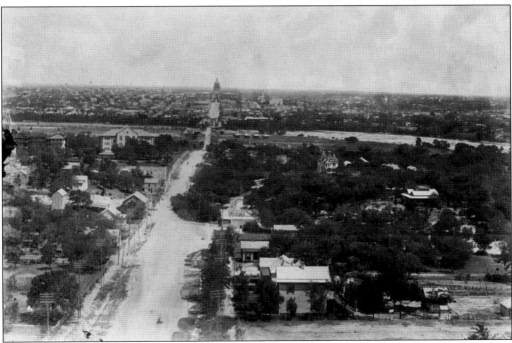

There had been more development by the first decade of the 1900s when this photograph was taken. The Swisher Addition in south Austin was established in 1877. That addition laid streets that run perpendicular to South Congress Avenue and have the names of family members and neighbors of the Swishers. The Fairview Park addition is east of South Congress Avenue and extends north to the Colorado River. (PICA 13968.)

13

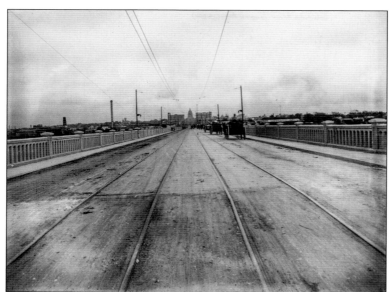

The Congress Avenue Bridge is pictured in 1910. This bridge was soon a notorious traffic bottleneck and would remain so until the Montopolis (1938) and Lamar (1941) Bridges were built. The Congress Avenue Bridge has been widened and improved since then and was renamed the Ann W. Richards Congress Avenue Bridge in 2006. (C02074.)

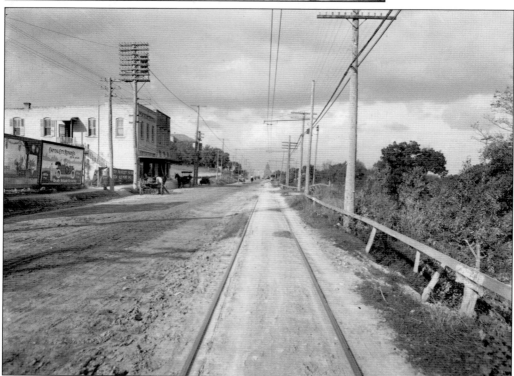

South Congress Avenue is pictured in 1914. The west side has businesses, and the right side has the trolley car tracks that were added when trolley service came to south Austin in 1911. South Congress Avenue began in the 1850s as a rural country road and followed the route of the old San Antonio Road. It was paved in 1931. This was the gateway for people coming into Austin from the south. Austin has grown outward in all directions, and South Congress Avenue remains a prominent artery in this vibrant city. (C00621.)

Travis Heights has beautiful varying terrain, scenic views, and thick tree coverage. This is the 1917 entrance to Travis Heights located at Riverside and Alameda Drives. Riverside Drive is now highly developed, but near the creeks it is still possible to see the rugged terrain and thick tree coverage. In 2018, the posts on each side of the entry are no longer there. (C03303.)

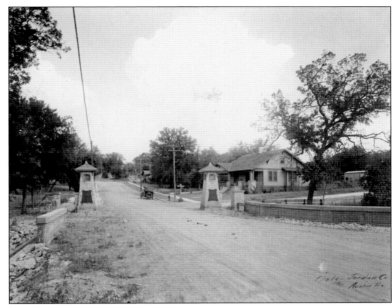

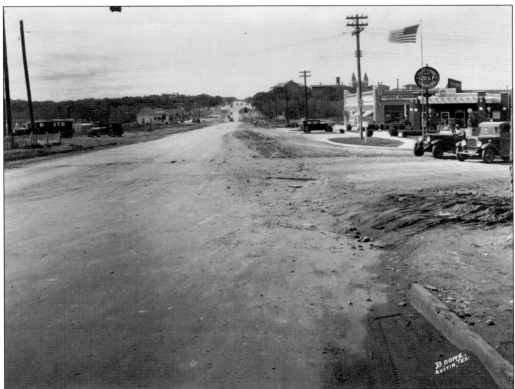

This is South Congress Avenue at Riverside Drive, in a view looking south around 1930. Riverside Drive has a deep rut in the road. There is a Gulf station (flying a flag) where a Chevron station stands today. Off in the distance, the tops of the tall administration building at the Texas School for the Deaf can be seen to the right side of South Congress. (PICA 20583.)

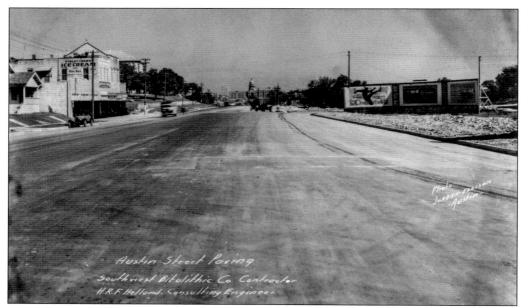

South Congress at Academy is pictured during street paving in 1929. On the left side of the block are the oldest south Austin store buildings owned by the Eck family. One of them has an ice-cream advertisement on its south side. On the right side of the photograph are billboards where, 20 years later, the Terrace Motor Hotel was established. (C00481.)

This is South Congress Avenue at Monroe Street, in a view looking north sometime between 1920 and 1939. On the right side of the street is the area where Congress Avenue Baptist Church was built, and on the left side is the 1500 block that later held businesses like Checker Front grocery store and today's Allens Boots. (C00491.)

This is South Congress Avenue at Nellie Street, in a view looking north sometime between 1920 and 1939. On the left side of the photograph are the retaining walls facing South Congress for the Texas School for the Deaf. On the right side is a barbecue restaurant. Years later, the Sam Houston Motel, which advertised that it was on the most beautiful entrance to any state capitol in the United States, was in that vicinity at 1005 South Congress Avenue. (C02113.) ·

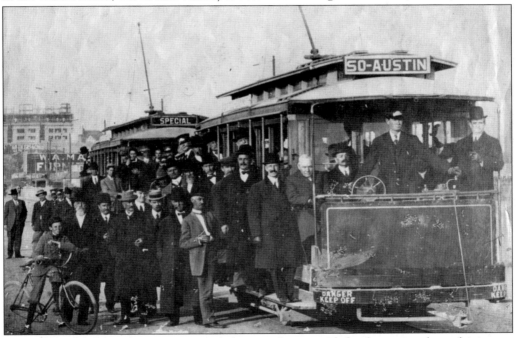

Murray Montgomery, a Texan writer and photographer, provided information about this image. This was the first day the present Congress Avenue Bridge was open for trolley transportation in January 1911. South Austin gained trolley car service after the completion of the concrete bridge. The trolley ran down South Congress to the 1900 block. It also branched eastward along Academy Drive and Riverside Drive over to Travis Heights Boulevard and then south on Travis Heights Boulevard to the 1900 block there. (PICA 06814.)

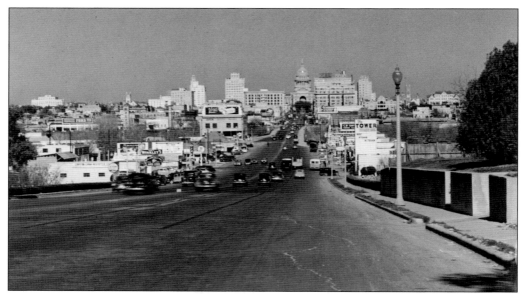

The view in this photograph from the 1100 block of South Congress Avenue looks north in 1948. The Dixie Grill is on the left side of the avenue. South Congress Avenue had numerous restaurants, motels, and gas stations by the mid-1940s. As the main highway into town, also known as the San Antonio Highway and US Highway 81, it was populated with businesses that catered to motorists. (C05767.)

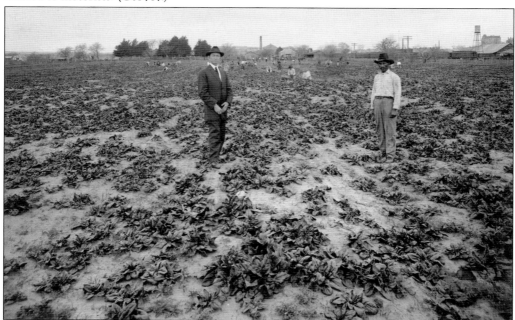

Men stand in a spinach field located on the south bank of the Colorado River in this undated photograph. People may think of cattle and cowboys when considering the rural life in Austin, but in the first half of the 1900s Austin had spinach, turnip, and other vegetable farming near the south side of the Colorado River. Many farmers on the south bank of the river, however, had their family farms wiped out in the great flood of 1935. (C09918.)

In this view looking south on South Congress Avenue, at Riverside Drive in 1951, buildings of the Texas School for the Deaf are visible on the right side. Part of the Night Hawk restaurant is visible on the right. The Sinclair gas station on the left is where today there is a Wells Fargo bank. On the left side, one can also see the Tower restaurant. (C06350.)

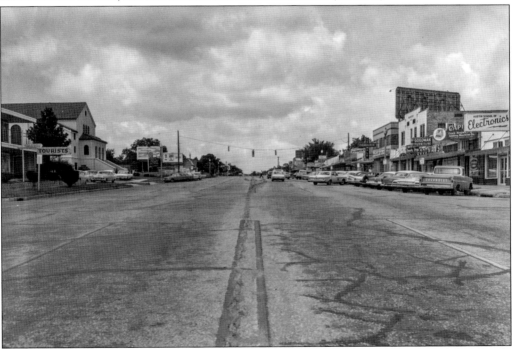

This is South Congress Avenue in 1964, in a view looking south at Monroe Street. The left side already has Congress Avenue Baptist Church. Next to it, with the sign reading "Tourists," is most likely Royal Courts, which advertised as "A Home Away from Home." On the right side is Austin School of Electronics, where Tesoros is today. Next door was Goodman Furniture, where Lucy in Disguise with Diamonds costume shop is located today. (PICA 17907.)

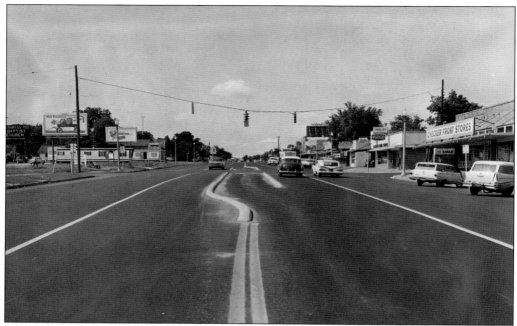

This is South Congress Avenue, in a view looking south from the traffic lights at Monroe Street in 1964. On the right side is Checker Front grocery store, where Allens Boots now stands. Just south of that is Saunders Drug Store, which is now the home of South Congress Café. The left side is not built up as much. Note the sign for the Congress Avenue Baptist Church. (PICA 17906.)

This is South Congress Avenue, in a view looking south from the light at Johanna Street in 1964. On the right side of the image is a highway marker sign for US 81, which shared this roadway with South Congress Avenue. Farther down on the right side is the Austin Theatre, located beside the intersection with Live Oak Street. On the left side are the grounds near Fulmore Junior High. (PICA 17904.)

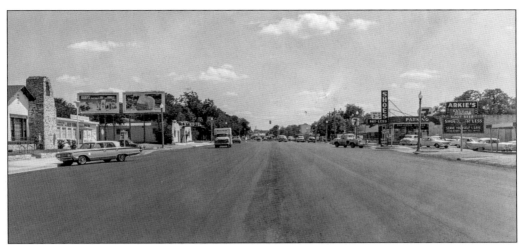

This view of South Congress Avenue in 1964 shows the Wilke-Clay funeral home on the left side, with a car in front. Also on the left side is the TV Motel. On the right is the sign for Arkie's Weber's Root Beer at the spot that later became Dan's Hamburgers. Dan Junk had worked at a nearby Burger Chef on east side of South Congress Avenue. With his skills and experience, he later opened his own hamburger restaurant. The restaurant was quite successful; other Austin sites were opened, and the menu expanded. In 1990, Dan's Hamburgers, on South Congress Avenue, became Fran's Hamburgers before closing in 2013. The site now has a Torchy's Tacos. Just south of Arkie's, there was a Payless Shoes store where there is now a Birds Barbershop. Also, a sign for 7-11 can be seen along the right side where Prima Dora Gifts now resides. (PICA 17903.)

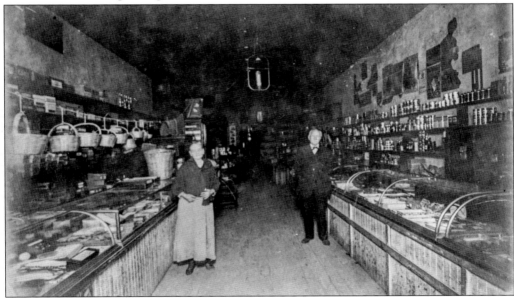

Margaret and William Jackson are pictured in the variety store at South Congress Avenue in 1892. This store has the present-day address of 1202 South Congress Avenue and is south Austin's oldest store. Opened by the Eck family, the store also was the first business in south Austin to have a business telephone. The Ecks bought the land that became their store, the adjacent stores and the Austin Motel in 1888. In 2017, the original store building housed Heritage Boots. (PICH 06066.)

The buildings at 1200, 1202, and 1204 South Congress Avenue, shown here in 1971, were all constructed by the Ecks and later owned by the next generation of the same family. In 1929, the block was advertised as the heart of south Austin's trade center. The storefronts expanded as businesses grew with the area. By the 1930s, there was Stewart Photo Company at 1206, a South Austin Barbershop at 1210, Grimmer Electrical Supply at 1208, and the large 1200 building was home to a Checker Front grocery store. (PICH 06056.)

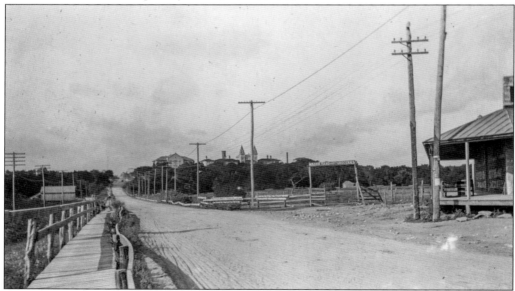

One of the earliest structures was the Powell Store and Stockyards, as seen in 1905. There were stockyards close to the south shore of the Colorado River, and when residential development started there were numerous complaints about the smell. Eventually, the stockyards were closed. In the mid-1800s, cattle were driven north and crossed the Colorado River close to this area. There had been cattle pens close to the water on both sides of the Colorado River. Farther south, there were liveries and boarding stables. (PICA 02553.)

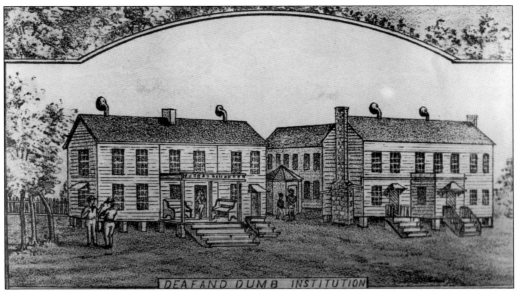

The Texas School for the Deaf (TSD) is probably the oldest of the earliest structures in south Austin. This drawing of it is presumed to be from the 1870s. The TSD was established, in 1856, as the "Texas Deaf and Dumb Asylum" and it is the oldest school in south Austin. The very first campus for this school was composed of three log cabins, one wood-frame house for dwelling, and a smokehouse. An early visitor was Gen. George Custer, who visited during his stay in Austin. He took lessons from TSD students and learned sign language so that he would be able to talk in sign language to Native Americans he encountered on the Great Plains. (C00502.)

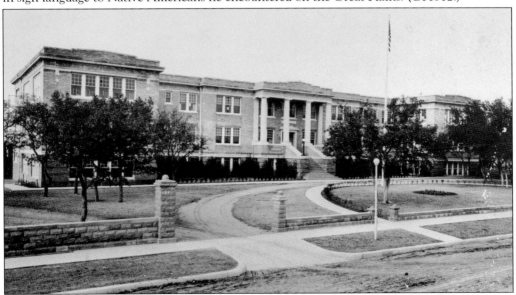

The Texas School for the Deaf is pictured in 1918. While south Austin was still relatively a very small part of Austin, the wooden structures at the school for the deaf had already been replaced with this handsome brick building at Newton Street. At the same time, businesses were opening along South Congress Avenue and farther east the residential areas of Travis Heights were rapidly growing. (PICA 12970.)

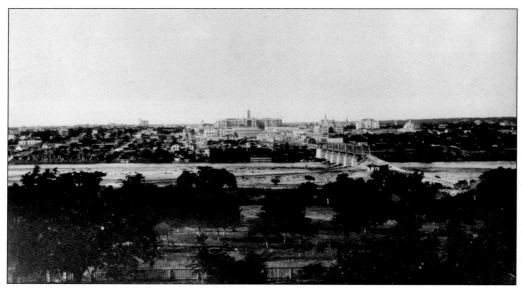

This bird's-eye view, taken sometime between 1882 and 1888 from the Texas School for the Deaf, shows the open spaces that surrounded the school for most of the first 50 years of its existence. The altitude needed to achieve this photograph was possible due to the school being built on a rise in the land as well and having tall twin towers. The wooden bridge that was washed away in the 1900 flood and downtown development are visible. (C00073.)

The original store, at 1200 South Congress Avenue, had become Handy Andy by 1933. It was also known as Stewarts Grocery. In the City of Austin directory, E.C. Stewart is listed as the manager. Stewart was the son-in-law of the original Eck family that opened a store in the same building in the 1800s. (PICA 15163.)

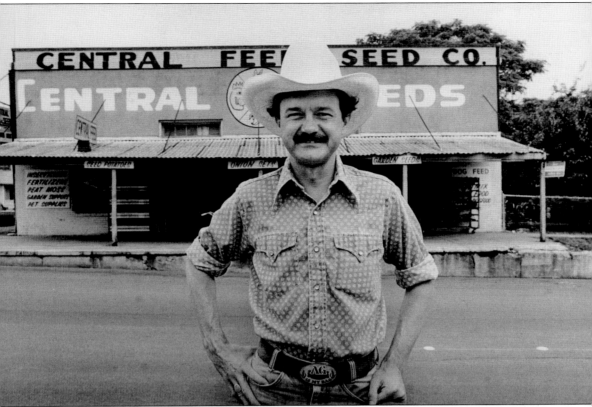

Jim Hightower is pictured in front of the Central Feed & Seed store at 1412 South Congress Avenue. It is another one of the earliest structures in south Austin. This photograph was taken during his 1982 campaign for commissioner of the Texas Department of Agriculture. South Congress Avenue was then somewhat run-down but still had remnants of its rural past, such as this store as well as nearby boot stores and Western saddleries. The 1900 City of Austin directory shows the same address to be C.B. Poteet Feed & Seed. A few years later, it became the Crawford Store. The Crawfords lost their son Earl Crawford in World War I. The City of Austin had a funeral procession down Congress Avenue for him in 1917. He was the first Austin military member to die in that war. After the Crawford store, it became the Central Feed & Seed No. 1, which sold supplies for farmers. In 1993, that business closed. Güero's opened in the same location a few years later. (Courtesy of Ave Bonar.)

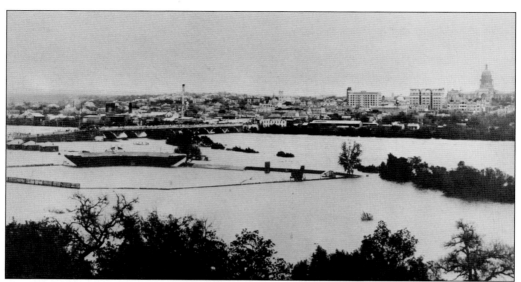

This view of the 1913 flood in south Austin illustrates how the fortunes and history of early south Austin were strongly influenced by the Colorado River. Floods were sporadic, damaging, and sometimes deadly. By the early 1900s, photography was increasingly used to capture the devastating floods. In various floods, Austin had vulnerable, low-lying developments that were devastated. (PICA 04009.)

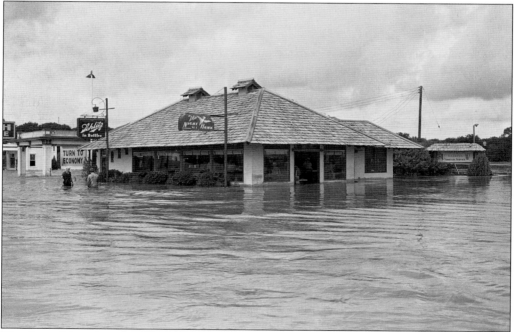

The date of this photograph is unknown, but it is labeled "The Great Flood," so presumably it is from 1935. The Night Hawk restaurant no. 1 is underwater. Heavy rains in May and June 1935 saturated the ground, and there were not enough runoff channels. Consequently, there was heavy flood damage in Austin including along the south shore of the Colorado River, which had a lot of recent construction and development by that time. (ND-A002-03.)

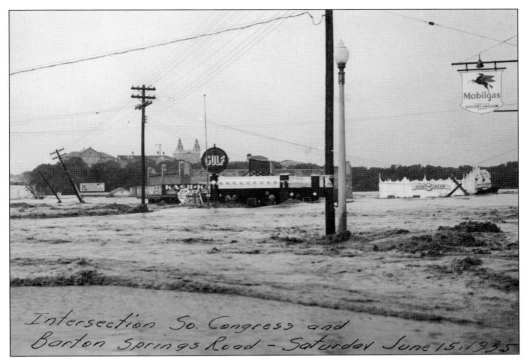

A startling scene is unfolding during the 1935 flood at the intersection of Barton Springs Road and South Congress Avenue. Barton Springs Road and nearby Riverside Drive were known to flood during heavy rainfalls. While the newly formed Lower Colorado River Authority was raising funds to build dams, floodwaters were inundating downtown and south Austin. (C09081.)

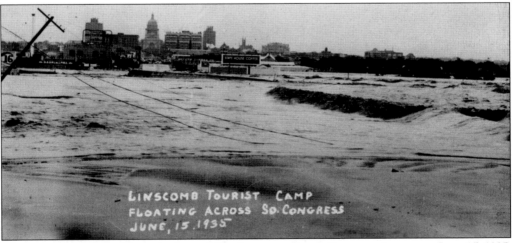

The Linscomb Tourist Camp is pictured floating across South Congress Avenue on June 15, 1935. The 1935 flood came after almost 20 inches of rain fell throughout the upriver areas and the hill country in early June. That was after nine inches of rain in late May had already saturated the ground. The LCRA was only a few months in existence and was still securing federal funds to build dams. The floodwaters swept in and submerged large parts of Austin. The Congress Avenue Bridge approach and large portions of downtown and south Austin were underwater. (PICA 04148.)

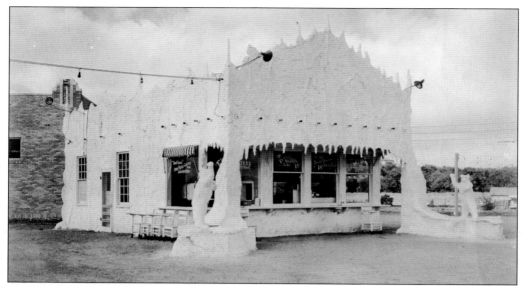

The Polar Bear Frozen Custard soft freeze stand was at South Congress Avenue and Barton Springs Road behind the Gulf Station. The frozen custard business was washed away in the 1935 flood. By the time the 1935 floodwaters receded, 13 people had died and much of Austin was left in ruins. Some, like nearby Night Hawk, were restored. But other businesses seem to have just moved. That may be what happened to Austin's original Pig Stand restaurant, which was close to the riverbank before disappearing from City of Austin directories in the mid-1930s. Years later, the Pig Stand opened in a location 1.5 miles farther south of the river. (PICA 15170.)

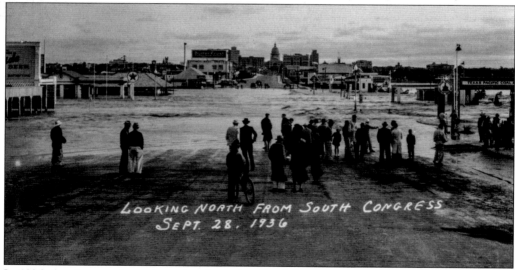

In 1936, Austin experienced another damaging flood that was created by two major storms that affected south Austin. In Austin, the volume of floodwater was greater than in the previous year, swelling the river for nearly three weeks. But businesses and residents alike had prepared for this flood to minimize the damage. South Austin residents and businesses had moved out valuables and possessions to high ground. Warning was given by trucks equipped with loudspeakers. Also, residents had learned from previous experiences that water could be supplied by the Norwood Estate water well and the artesian well at Stacy Park for backup water supplies. (PICA 04169.)

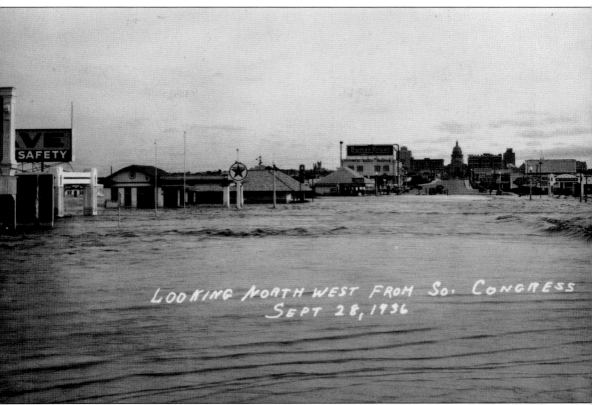

The view in this image looks northwest from South Congress Avenue during the September 1936 flood in south Austin. Record-breaking rainfall and flooding combined with ground saturation and no runoff channels in 1935, 1936, and 1938 illustrate the potential power of unchecked and rampaging floods along the Colorado River. Residents and politicians knew they needed to control the water levels and minimize flooding. With the formation of the LCRA and the completion of the Tom Miller Dam on the Colorado in 1940 as well as other dams built upstream, severely damaging floods have not occurred in Austin since the late 1930s. (PICA 04170.)

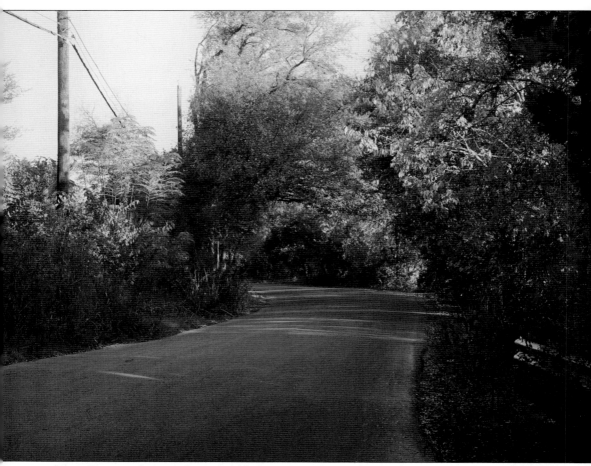

This photograph was taken on Old East Riverside Drive with a view looking toward Summit Street just east of Interstate 35. This short segment of Old East Riverside Drive still has the original undeveloped look even though it is in the middle of a residential area. When the Travis Heights subdivision was laid out, the lots were located on the higher ground while the streets were constructed in the lower sections. The early developers spent considerable money having the streets graded. They also tarviated (paved) Riverside Drive, which was once an old sand road lying near the river. (Author's collection.)

Two

RESIDENTIAL

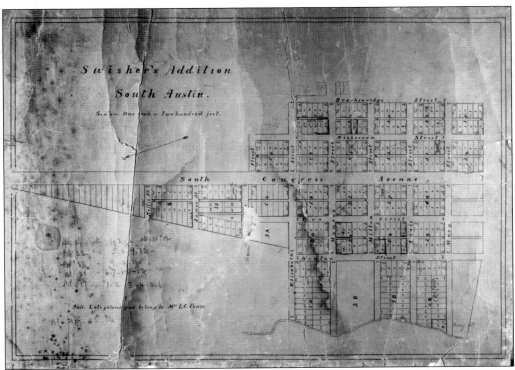

This is an illustration of the 1877 Swisher Addition to south Austin. This was the first development south of the river. The Swisher family subdivided about 23 acres of their family farm along the San Antonio Road and allotted a right-of-way through the center of this residential addition. The wide avenue was laid out in a direct line with Congress Avenue on the north side of the river. The Swishers named the streets after members of the family and neighbors, including Milton, Monroe, James, Annie, Nellie, Elizabeth, Mary, Johanna, and Eva. (PICA 30861/Map L-6.)

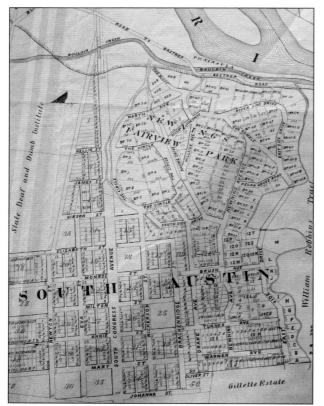

This detail from an 1889 topographical map by John F. Pope shows the Travis Heights Neighborhood. In 1886, Charles Newning bought the northeastern portion of the Swisher farm and developed Fairview Park over a hilly area with city views from its hillsides and terraces. Fairview Park is not a neat grid but is rather laid out in large lots with a rambling array of connecting streets that followed the contours of the area hills and bluffs above the Colorado River and Blunn Creek. Newning intended to sell large lots for grand homes. In 1913, Gen. William Harwood Stacy (Newning's partner) and Stacy's sons began development of Travis Heights. Designed with a range of lot sizes, the Travis Heights residential subdivision lots were heavily promoted and sold well. Stacy provided streetcar service from Travis Heights Boulevard. (Map #L-32(OS), AHC.)

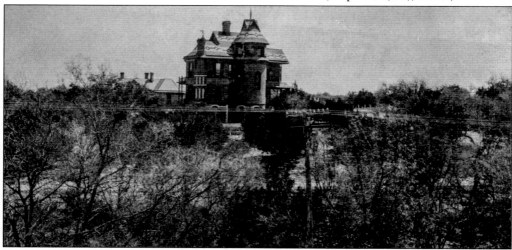

This home at 106 Academy Drive is now demolished. Charles A. Newning owned two Fairview Park residences and reportedly built four houses in that area. The houses in Fairview Park were handsome and substantial. Unfortunately, Newning's Fairview Park did not develop as well as planned, and many of the larger lots ended up subdivided into smaller sizes. A newspaper article from 1888 mentions a "Midsummer German" was held at Fairview Park in the evening, with refreshments and dancing. Midsummer parties were thought to have been brought over to Texas from Germany and were celebrated in the 1800s. (PICH 01114.)

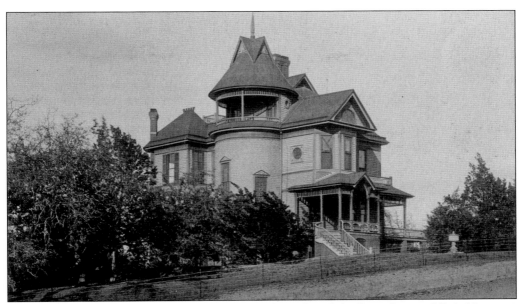

Once located at 108 Academy Drive, this is the (now-demolished) residence of C.A. Newning that he named Cedarlawn. Newning was both a county commissioner and a developer. When he developed Fairview Park, he built houses, brought in sewer lines, and ensured bus service for the residents. He came to Austin from New England, and as a young man he staked his fortunes on the Fairview Park subdivision. The neighborhood grew slowly at first, even with a permanent bridge. The success of the commercial and livestock-related commercial area of South Congress Avenue may have undermined the residential appeal of adjacent Fairview Park. Newning eventually left Austin and died in Houston in 1924. (PICH 01115.)

This house, built in 1888, is a historic landmark: the Miller-Crockett House at 112 Academy Drive. Once the home of Leslie and Ann Miller Crockett, the building is now Hotel Saint Cecelia, a luxury boutique hotel. Leslie Crockett was a relative of famous frontiersman Davy Crockett. Crockett's wife, Ann Miller-Crockett, was born in the house. Later, she gained the distinction of being the first woman president of the Austin Real Estate Board. Her Austin real estate office was located at the next-door Terrace Motor Hotel. (Author's collection.)

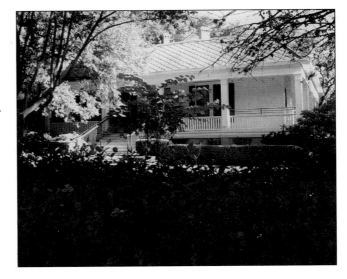

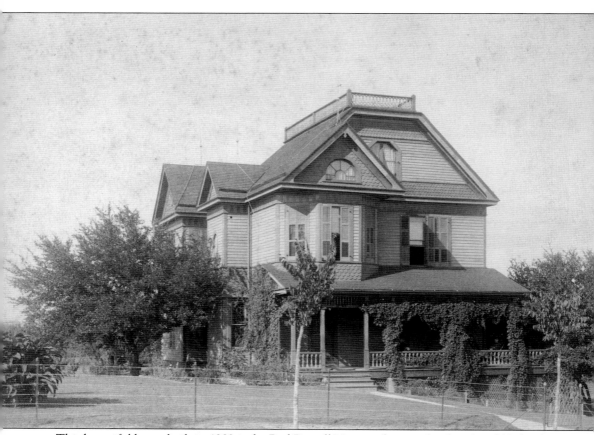

This beautiful home built in 1882 is the Red-Purcell House, a historic landmark at 210 Academy Drive. This house had originally been a model home built by developer Charles A. Newning. It is reported to be the last remaining Newning-built house. Dr. Red bought this house in 1916, and his family held on to it for nearly 100 years. The Red and related Purcell families were involved in medicine and education, including the Texas School for the Deaf. The house is now owned by Colin Corgan, who is researching the history of the house and the grounds. (PICH 07518.)

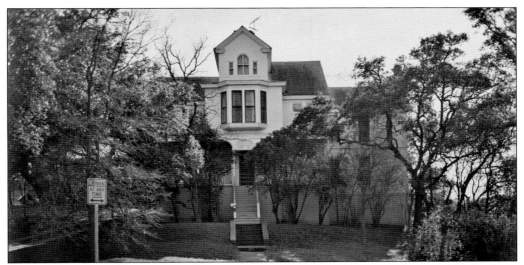

Built in 1886, this is the 14-room, 4,300-square-foot towering Warner-Lucas home at 303 Academy Drive. George Warner, the original owner of the house, was a partner in the development of the Fairview Park subdivision. The exterior is classic Queen Anne fashion with each of the 3½ stories covered in different material. It was purchased in 1915 by the prosperous Lucas family, who lived in it until the mid-1940s. Georgia Lucas was born there in 1917 and lived there until the mid-1940s, when she and her widowed mother moved to the Driskill Hotel. They kept the house for sentimental reasons. (Photo courtesy of Texas Historical Commission.)

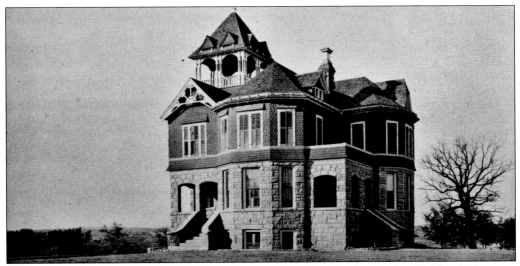

Built in 1890 and designated as a Texas Historical Landmark, the Mather-Kirkland House at 400 Academy Drive is also known as "the Academy." This house was originally built by Myron Mather, president of Austin, Water, Light & Power Co., using granite left over from building the capitol. After that it was lived in for a time by a member of the Texas Supreme Court. During the 1920s, it served as the Austin Military School; hence, the nickname "the Academy." During that time, the acreage went all the way to the cliff on Riverside Drive. It was owned in the 1940s by Roy and Elithe Kirkland. Roy Kirkland was an osteopath and surgeon, and Elithe was a writer. (Photo courtesy of Texas Historical Commission.)

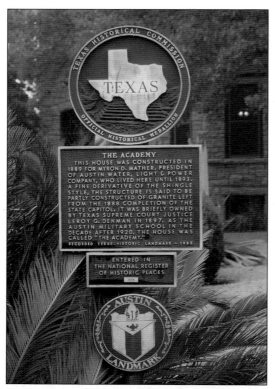

This is the historical marker for the Mather-Kirkland House, also known as the Academy. This house has a rich, diverse history but almost fell into ruin before it was bought and restored in 1982. The house became a Texas Historic Landmark in 1985, part of the National Register of Historic Places in 1978, and it is an Austin Landmark. (Author's collection.)

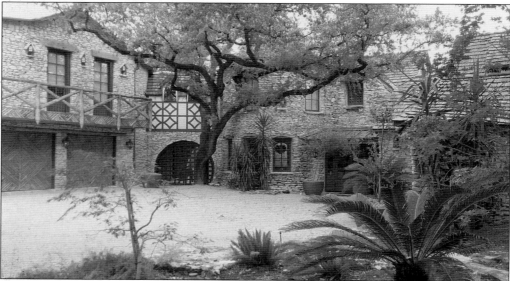

Built in 1927–1931, this is the General Wakefield home at 220 Bonniview. Some of the design elements and materials used are picturesque and unusual. It is reminiscent of a Norman French farmhouse, but overall it reflects the personality of its owner, General Wakefield, who directed the design and the construction. Wakefield served in World War I in France, where he became familiar with the architecture of the countryside there. After the war, he served in various political positions. (Author's collection.)

This house at 605 Academy Drive was built in 1924. The house is listed in an old advertisement as follows: "55x200 lot, 5 room – frame – good condition." In 1930, Harry and Laura Bengston lived there. He was chief clerk for the State of Texas. She was active in the Methodist Church Ladies Aid Society and played piano at events. (PICH 07077.)

This house was built in 1930 and was located at 607 Academy Drive. In 1954, Billy Hill, who was night manager at the Terrace Motor Hotel, lived there with his wife and family. Born in California but raised in Texas, Hill graduated from Austin High School. After military service, he had a long career in hotel management—much of it in Austin. (PICH 12994.)

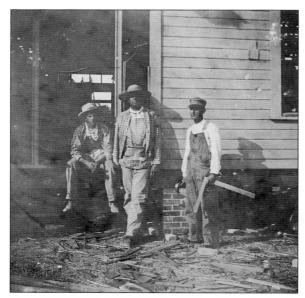

W.H. Davis (left), George Brooks (center), and Robert Rives, shown here, were the carpenters that built the house for W.H. and his wife, Luella Davis, in 1907 at 1203 Newning Avenue. At the turn of the 20th century, the Davises had been schoolmates, both having attended Gallaudet College for the Deaf in Washington, DC. Davis, Brooks, and Rives were all graduates of, as well as teachers at, the nearby Texas School for the Deaf. The Robert Rives House was built nearby at 1301 Newning. Both houses were walking distance from the school. Rives was the first graduate of the Texas School for the Deaf to attend Gallaudet College. (Courtesy of the Texas School for the Deaf.)

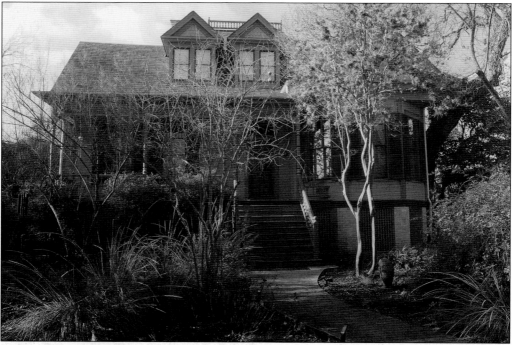

This Queen Anne–style cottage, the Wilkins-Heath House, is a designated historic landmark at 1208 Newning Avenue built in 1890. It was one of the original two dozen homes in Fairview Park. Sisters Sarah "Sallie" Day and Virginia Alma Day Wilkins lived in it along with Alma's husband, Frank Wilkins. James Monroe "Doc" Day, the father of the two sisters, is known to have built the house for them. Local legend is that he once won the Driskill Hotel briefly in a poker game. The 1889–1890 City of Austin directory shows J.M. Day as the proprietor of the Driskill Hotel as well as the president of Day Land and Cattle Company. J.M. Day was well known locally as one of Texas's cattle kings. (Author's collection.)

The house at 1214 Newning Avenue, a designated historic landmark, was built in 1898. It was once the residence of Dr. Alberto G. Garcia, a native of Mexico and the first Latin American physician to establish a practice in Austin. He also founded a Spanish-language newspaper, *La Vanguardia*. The mission of *La Vanguardia* was to encourage the Texas Hispanic community to become literate in English, understand the voting process, and encourage voter registration and property ownership, which was a prerequisite for voting at that time, so that the Mexican American community could improve the status of its citizens. Dr. Garcia died at this home in 1962 when he was 73 years old. (Author's collection.)

The beautiful, grand house at 1304 Newning Avenue was built in 1910 and is mostly known as being the home of Tom and Lillian Gullett, who lived in it for decades. Tom was the managing principal for Austin schools. This house also seems to have been built by the same cattleman, J.M. Day, who built 1208 Newning Avenue. After the Gullets' ownership, at some point, the house was converted into apartments. Fortunately, the house was renovated in 1989 according to its original plans and since then has operated as a bed-and-breakfast. (Author's collection.)

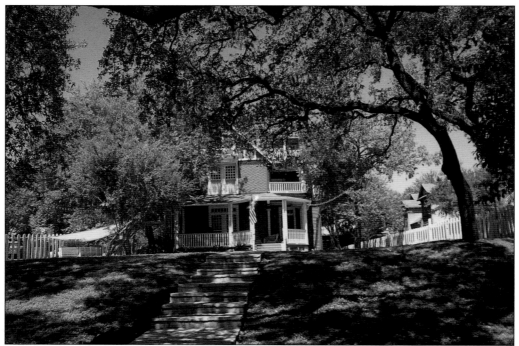

This designated historic landmark house at 1312 Newning Avenue was built in 1890. It was the home of Florence Richey, whose career in the field of home economics spanned over 40 years. Her teaching career in Austin included employment at McCallum High School and the University of Texas. When she retired in 1969, she went on to become a businesswoman managing her diverse business concerns. Her husband, W.E. Richey, was real estate broker and independent oil operator. (Author's collection.)

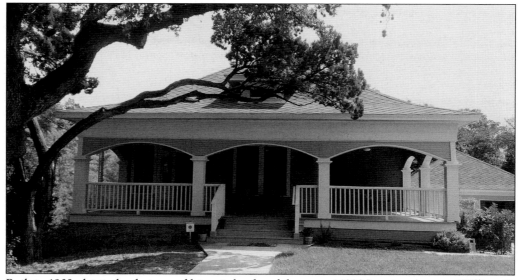

Built in 1903, this is the designated historic landmark house at 1409 Newning Avenue. William B. and Nancy Milam lived there in the mid-1900s. His business, Milam's Package Store, was located at 1805 East Sixth Street. (Author's collection.)

The designated historic landmark Dumble-Boatright House was built in 1900 at 1419 Newning Avenue. This Victorian residence was originally owned by Edwin Dumble, a state geologist. He carefully selected for his homesite soil that sat on solid limestone. Mody C. Boatright, a friend of J. Frank Dobie's, later lived there. He was in the English department at UT and was a well-known Texas folklorist. His prominent books include *Tall Tales from Texas Cow Camps* and *Folk Laughter on the American Frontier.* (Author's collection.)

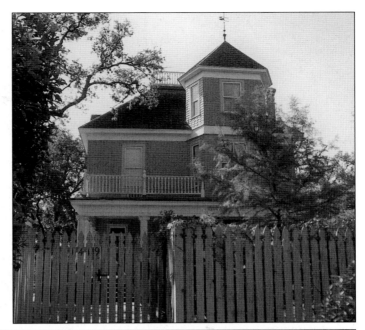

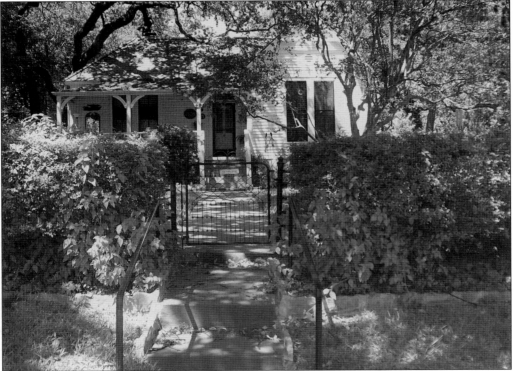

Built in 1890, this is the designated historic landmark house at 1508 Newning Avenue. Onetime inhabitants were Albert and Nellie Thomas. Albert was a well-known watchmaker and a longtime resident of Austin. The house is set off from the street a good distance and has abundant trees and shrubs like many of the houses in this area. (Author's collection.)

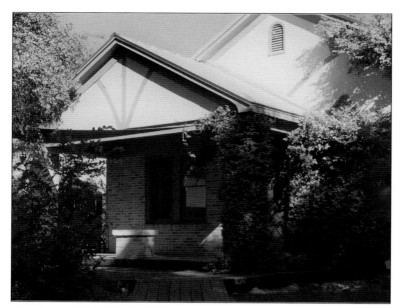

This house at 110 Academy Drive was built in 1930. During the 1960s, it was once the former Terrace Motor Hotel manager's house. It is on the north side of Academy Drive near the hotel suites that were once located there. The building was torn down in 2017 for the ongoing construction of a new boutique hotel going up in the area. (Author's collection.)

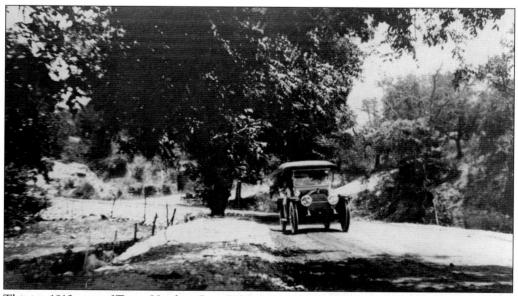

This is a 1913 view of Travis Heights. Gen. W.H. Stacy, Charles Newning's partner, had envisioned extending south Austin to the east beyond Fairview Park. The Travis Heights subdivision was designed with a variety of lot sizes. Streetcar rides were provided to prospective buyers from the capital to the area before houses were even built. General Stacy built his own beautiful home at 1201 Travis Heights Boulevard. Around this south Austin area, stately trees line the streets. The houses built on the hills have magnificent views of downtown Austin. Stacy died while working at his desk in 1928. After his passing, Stacy's three sons carried on furthering the development of the Travis Heights addition, of which 600 lots had been sold by then. (AR-X-016-A062.)

Built in 1921, this is the designated historic landmark Stacy House at 1201 Travis Heights Boulevard. Gen. W.H. Stacy built this house for himself. His son Harwood Stacy lived in the house after his father's passing. Harwood, who was in the real estate business along with his father and brother, died in the house in 1947. (Author's collection.)

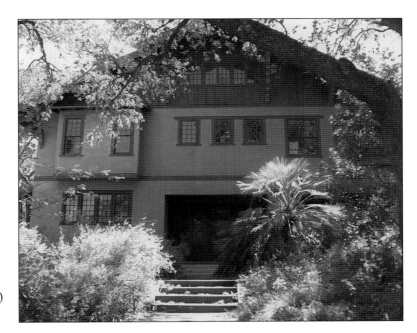

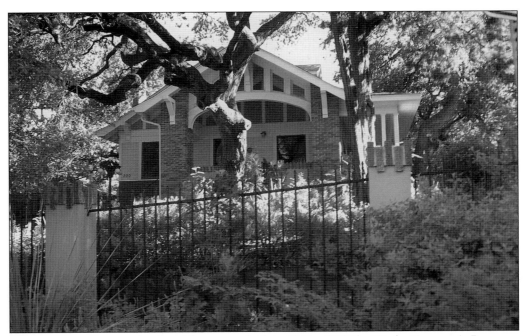

This designated historic landmark house was built in 1917 at 200 The Circle. Newton A. Brunson, who lived there, had a business downtown that was advertised in 1940 as an "Authorized Dealer of Majestic Radios and Refrigerators." In the original developer's plans for this street, The Circle made a complete circular path around a hill. The circle has been reduced over the years, but there is still some curvature to the street. There was a KKK meeting hall at 201 The Circle, according to City of Austin directories from the 1920s. But that address no longer exists. (Author's collection.)

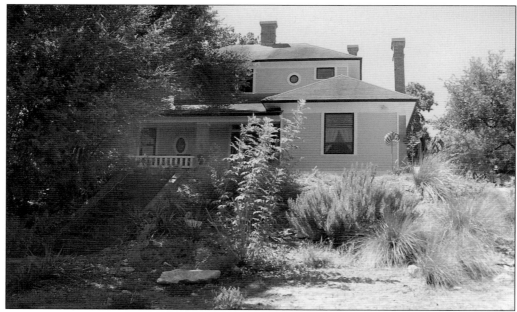

Built in 1907, this is the designated historic landmark house at 405 East Monroe Street. The first resident of that house seems to have been Elmer E. Ross, who was listed in a city directory as a carpenter. With the current price of real estate in the area today, it is difficult now for a craftsman to afford a house like this in Travis Heights. (Author's collection.)

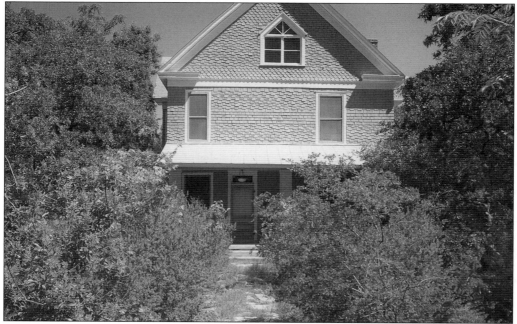

This designated historic landmark house was built in 1900 at 410 East Monroe Street. Early inhabitants were George P. and Alberta (Berta) Searight. George was the commissioner of Streets and Public Improvements during the administration of Mayor W.D. Yett in the early 1920s. Their daughter Mary Belle taught at the Texas School for the Deaf. (Author's collection.)

This designated historic landmark house at 1007 Milam Place was built in 1914. In 1939, state commissioner of agriculture J.E. McDonald lived there with his wife, Lizzie McDonald. McDonald was a farmer himself. He saw the role of the Agriculture Commission as the administrator of regulatory agricultural laws, such as for inspection and certifications. (Author's collection.)

This residence at 106 East Mary Street was built in 1914. In the 1950s, this was the home of Charlie and Julia Dye. Mr. Dye had a business, Dye Sales and Service, at 1801 South Congress Avenue. Mrs. Dye served on the parent board of William B. Travis High School in the 1950s. The house is painted in beautiful deep colors and stands out across the street from the Fulmore running track. (Author's collection.)

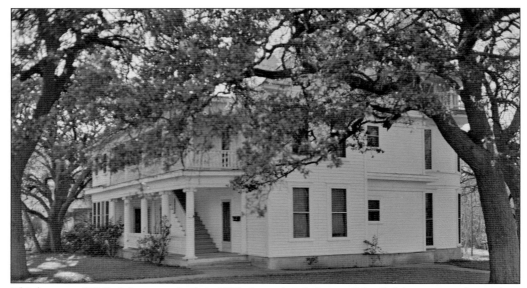

This house at 309 Park Lane was built in 1930. An early inhabitant, John B. Moore, was a descendant of one of the three original families in the area when it first opened to settlement. In 1935, a birthday party was held at this address for Moore's mother, Martha Burleson Moore, who was turning 90 years old. She had been born at the nearby Hill's Prairie, where her family went to escape the violence of a Comanche raid east of Austin. (Photo courtesy of Texas Historical Commission.)

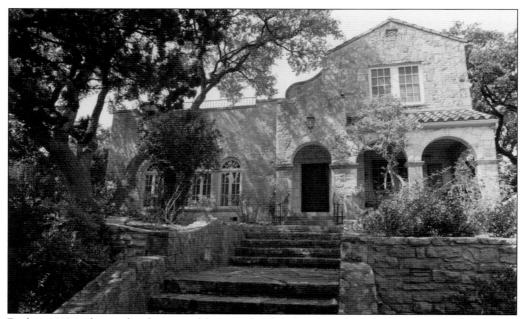

Built in 1934, this is the designated historic landmark Reuter House at 806 Rosedale Terrace. This Spanish Colonial Revival structure was built by Louis and Mathilde Reuter. They included cove ceilings for acoustics, as they envisioned the house as a setting for musical events. Louis Reuter was a successful groceryman. Mathilde opened a voice and piano studio. (Photo courtesy of Texas Historical Commission.)

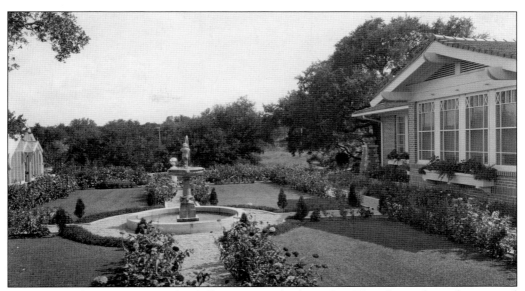

The Norwood House at 1012 Edgecliff Terrace was built in 1914. This elegant bungalow, named Norcliff by its owners Ollie and Calie Norwood, was classic Arts & Crafts in the progressive California Craftsman style. Built on the bluffs above the south banks of the Colorado River, just west of the area where Interstate 35 now crosses Lady Bird Lake, it has a spectacular view of the city. Ollie Norwood made his fortune in the volatile bond market and leveraged his assets to bankroll ambitious projects. He is perhaps best known for building the downtown Motoramp and 16-story Norwood Tower on Seventh Street. The house was occupied until the mid-1980s, when the City of Austin bought it for parkland but never designated funds to properly maintain or renovate the property. The estate has been heavily damaged by vandals, but the home and immediate grounds are now being restored by the Norwood Park Foundation. (PICH 06754.)

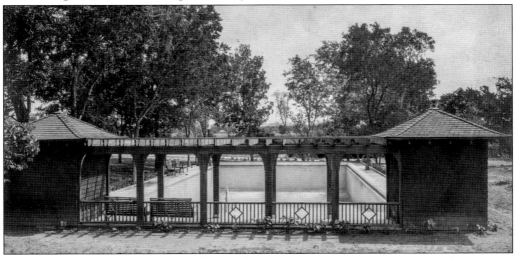

The swimming pool at 1012 Edgecliff Terrace was the first geothermal, spring-fed swimming pool in Austin. It has been filled in, and the bathhouses and pergola were vandalized and are no longer there. Some Austin residents recall sneaking into the pool at night for a moonlight swim in the 1970s, after a night at the Vulcan Gas Company or the Armadillo World Headquarters. (PICH 06763.)

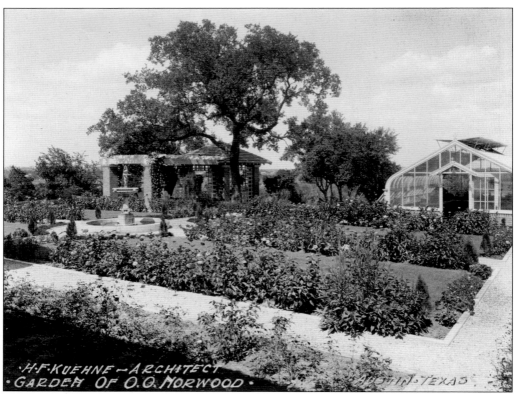

H·F·KUEHNE – ARCHITECT · GARDEN OF O.O. NORWOOD · AUSTIN, TEXAS

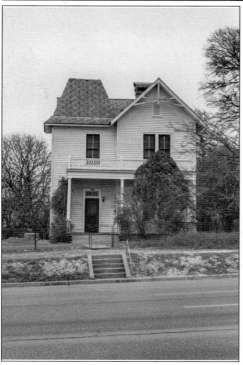

The gardens, greenhouse, and gazebo at 1012 Edgecliff Terrace are pictured here. The Norwood estate was a five-acre site that included formal terraced gardens, a greenhouse, a fountain, a "teahouse" gazebo, tennis courts, additional bungalows for the owner's parents, a swimming pool, and a large pecan orchard. The Norwood homesite is currently maintained by the Norwood Park Foundation, a nonprofit working to restore and repurpose the house and grounds to serve as a premier rental venue and cultural space. The house has been stabilized and the beautiful heritage oaks restored to full health, but most of the renovation work remains to be done. (PICH 06755.)

This designated historic landmark house was built in 1905 at 1403 South Congress Avenue. The 1924 City of Austin directory lists it as inhabited by the Alfred (deceased) and Tennessee "Tennie" Todd family. This house sits in the middle of a popular section of South Congress Avenue along a stretch that was had a lot of recent commercial development. (PICH 06059.)

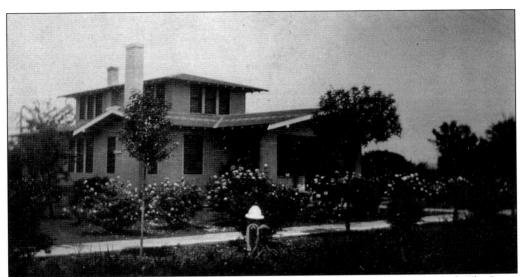

This house at 2116 South Congress Avenue was the original Long family homestead. The Long Vacuum & Appliance store sits just next door on the southside of the house at 2118 South Congress Avenue. But the house was originally on the south side of the store until the land under the house was sold to the company that built the Austin Theatre in 1939. Welden Long remembers that after the sale the house was moved to the northside of their land. Unfortunately, the new theatre building dominated the view from the Longs' south-facing door much to the everlasting disappointment of his grandmother. (Courtesy of Weldon Long.)

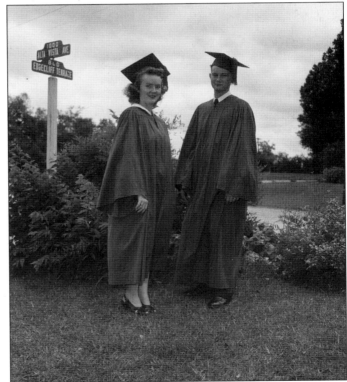

Dean and Virginia Davis are pictured in 1947. These siblings had graduated from Austin High School in 1947 in the days before there was a high school on the south side. They are standing at the intersection of Edgecliff Terrace and Alta Vista Avenue. The Davis family lived nearby at 1000 Alta Vista Avenue in a house built in 1923. Their father, Marcus Davis, was listed in the city directory as a salesman of the Cooper Wholesale Dry Goods store. (ND-47-144-03.)

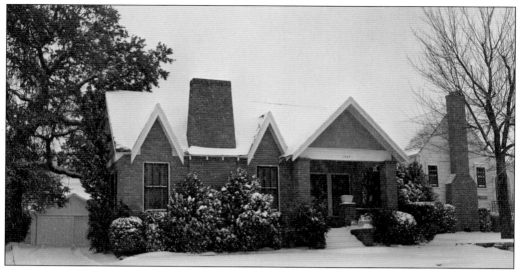

The house of Clarence and Laura Rhemann is pictured in 1949 during one of Austin's rare snowfalls. This house was built in 1932 at 1607 Alta Vista Avenue in Travis Heights. City directories show that Clarence was employed at the Electrical and Steam Engineers Department for the City of Austin. (ND-49-336-01.)

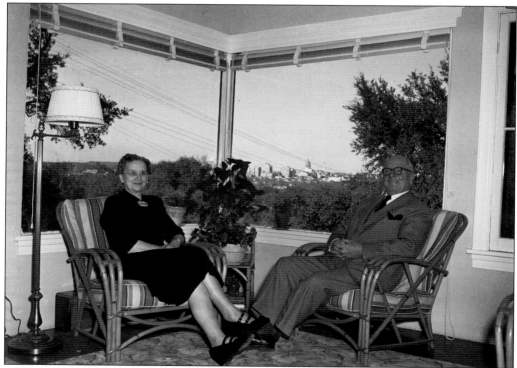

William R. and Lula S. Nabours are pictured in 1951 at their home at 1300 Travis Heights Boulevard, enjoying their enviable view of downtown Austin. William was chairman of the Tax Board of Equalization in 1954. That board determined how much Austinites would pay in taxes. He was reportedly a retired businessman by then. (ND-51-365-01.)

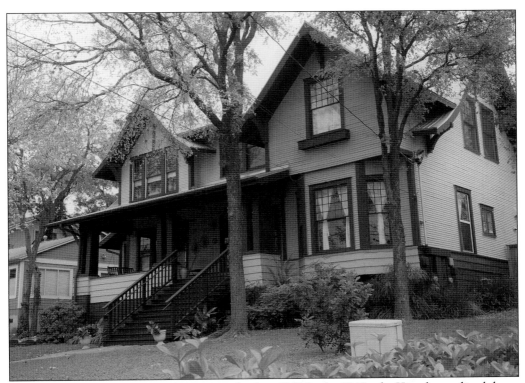

This home at 1001 East Riverside Drive was built in 1917. In the 1940s, the Kingsberrys lived there. E.G. Kingsberry was manager of the Texan Hotel, which was once located at 121 West Seventh Street in downtown Austin. The hotel had the slogan "A friendly place in a friendly city." This Victorian home was renovated in 2010 into a bed-and-breakfast. (Author's collection.)

The house of Gillespie Stacy at 1300 Alta Vista Avenue was built in 1926. Gillespie was one of the sons of the original Travis Heights developer, W.H. Stacy. When Gillespie died, many prominent people attended his funeral, including former governor Dan Moody and his wife, as well as Dr. Daniel Penick, who coached Gillespie when he helped win the Southwest Conference tennis title during his university years. (Author's collection.)

This house at 1809 Drake Avenue was built in 1922. In 1925 and again in 1938, the house was listed for rent as a four-room house with a sleeping porch. The sleeping porch, most likely, was the room separated from the kitchen with a wide doorway, which would have helped provide ventilation and cooling breezes in the days before air-conditioning. The porch space was later converted to a standard room. The separate front door was maintained, allowing for a room boarder. There are numerous other small houses in the immediate area designed in the same way. (Author's collection.)

This house at 500 East Monroe Street was built in 1923. In 1939, J.T. Pierce and his wife, Mary, lived there. J.T. was a salesman for the Walter Tips Company, which started as a hardware store in Austin during the 1850s. It was successful and eventually branched out into other areas, such as heavy machinery and leather and wood trappings for horse-drawn vehicles and servicing machinery. In the 1900s, a division was started building engines. (Author's collection.)

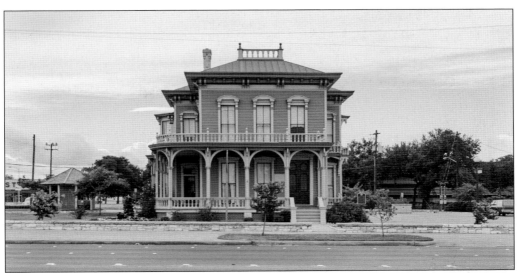

The Walter Tips House was built in 1876 and was moved from downtown by the capitol to the corner of South Congress Avenue and Oltorf Street. Neal Spelce, the longtime Austin news anchor and businessman, along with former Austin city councilwoman Emma Lou Linn, share some memories of that in their 2107 Austin History Center oral history contributions. Spelce recalls the humorous story about when the Tips house was moved southward on Congress Avenue. During the night, a man stumbled out of a Sixth Street bar. As he saw the large house on a trailer going by, he mistakenly exclaimed, "My God, they're moving the Driskill [Hotel]!" Moving the house was a tremendous undertaking, as the house weighed 166,000 pounds. Linn also recalled the efforts to save the beautiful but condemned house and that the move took place despite concerns over the stability of the Congress Avenue Bridge supporting the weight of the house. (Photo courtesy of Texas Historical Commission.)

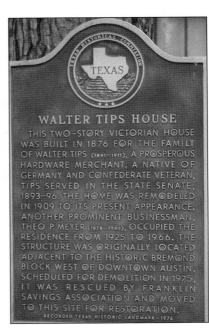

This is the historical marker for the Walter Tips House. Tips was a prominent businessman who, in 1881, sold his interests for his original business in New Braunfels to his partners and devoted himself to the hardware business in Austin. Tips served as chief administrator until his death in 1911. This grand and stately house was used to entertain at least two presidents: William McKinley in 1901 and Theodore Roosevelt in 1905. In 1975, the house was moved from the downtown area to the intersection of South Congress Avenue and Oltorf Street, where it operated first as a Franklin Savings and Loan company and later as a Wells Fargo bank branch. In 2017 the house became a Western boot store. (Author's collection.)

This English-style house at 1304 Alta Vista Avenue was built in 1936 by prominent grocer and Austin civic leader Eugene A. Murchison. He served for many years as a member and president of the Austin School Board. He was also active in the Boy Scouts, Austin Rotary Club, and the Spanish-American War Veterans. (Author's collection.)

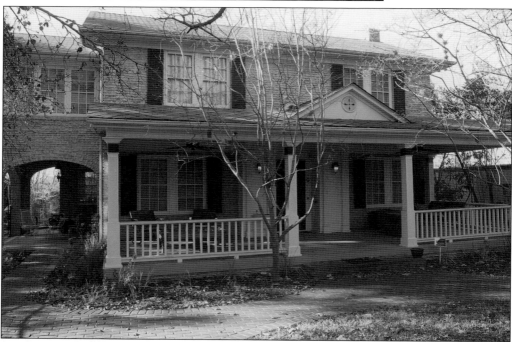

This house was built at 1308 Alta Vista Avenue in 1936 for Alden and Mabel Davis. Mabel was well known in Austin for her civic leadership and her passion for nature and gardening. She headed Red Cross volunteers during World War II and was president of the Violet Crown Garden Club, the Humane Society, and the Austin Women's Club. She pushed Austin's Mayor Miller to build a tuberculosis hospital when there was an outbreak. The Zilker Rose Garden was named after her. In addition to that, in the late 1970s the City of Austin named Southeast District Park Mabel Davis District Park. Thanks to assistance from a federal grant, this park has an Olympic-size swimming pool. Mabel Davis Park and Swimming Pool are located less than three miles away from where Mabel lived. (Author's collection.)

Three

EDUCATION

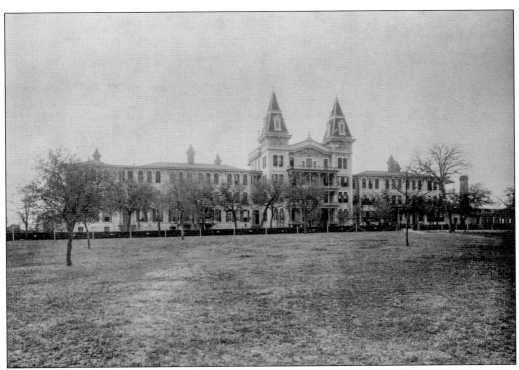

The striking twin spires of the Texas School for the Deaf (TSD) seen here in 1894 are now demolished. On January 2, 1857, the school was opened with only three students enrolled—all boys. Having substantial newer brick buildings and hundreds of pupils, the TSD is the oldest continually operating public school in Texas. In 2018, the school remains at 1102 South Congress Avenue. (PICH 01628.)

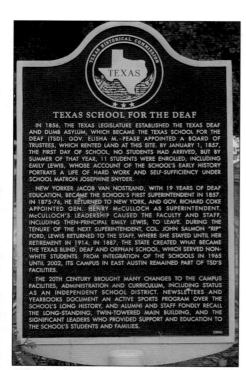

TEXAS SCHOOL FOR THE DEAF

IN 1856, THE TEXAS LEGISLATURE ESTABLISHED THE TEXAS DEAF AND DUMB ASYLUM, WHICH BECAME THE TEXAS SCHOOL FOR THE DEAF (TSD). GOV. ELISHA M. PEASE APPOINTED A BOARD OF TRUSTEES, WHICH RENTED LAND AT THIS SITE. BY JANUARY 1, 1857, THE FIRST DAY OF SCHOOL, NO STUDENTS HAD ARRIVED, BUT BY SUMMER OF THAT YEAR, 11 STUDENTS WERE ENROLLED, INCLUDING EMILY LEWIS, WHOSE ACCOUNT OF THE SCHOOL'S EARLY HISTORY PORTRAYS A LIFE OF HARD WORK AND SELF-SUFFICIENCY UNDER SCHOOL MATRON JOSEPHINE SNYDER.

NEW YORKER JACOB VAN NOSTRAND, WITH 19 YEARS OF DEAF EDUCATION, BECAME THE SCHOOL'S FIRST SUPERINTENDENT IN 1857. IN 1875-76, HE RETURNED TO NEW YORK, AND GOV. RICHARD COKE APPOINTED GEN. HENRY McCULLOCH AS SUPERINTENDENT. McCULLOCH'S LEADERSHIP CAUSED THE FACULTY AND STAFF, INCLUDING THEN-PRINCIPAL EMILY LEWIS, TO LEAVE. DURING THE TENURE OF THE NEXT SUPERINTENDENT, COL. JOHN SALMON "RIP" FORD, LEWIS RETURNED TO THE STAFF, WHERE SHE STAYED UNTIL HER RETIREMENT IN 1914. IN 1887, THE STATE CREATED WHAT BECAME THE TEXAS BLIND, DEAF AND ORPHAN SCHOOL, WHICH SERVED NON-WHITE STUDENTS. FROM INTEGRATION OF THE SCHOOLS IN 1965 UNTIL 2002, ITS CAMPUS IN EAST AUSTIN REMAINED PART OF TSD'S FACILITIES.

THE 20TH CENTURY BROUGHT MANY CHANGES TO THE CAMPUS FACILITIES, ADMINISTRATION AND CURRICULUM, INCLUDING STATUS AS AN INDEPENDENT SCHOOL DISTRICT. NEWSLETTERS AND YEARBOOKS DOCUMENT AN ACTIVE SPORTS PROGRAM OVER THE SCHOOL'S LONG HISTORY, AND ALUMNI AND STAFF FONDLY RECALL THE LONG-STANDING, TWIN-TOWERED MAIN BUILDING, AND THE SIGNIFICANT LEADERS WHO PROVIDED SUPPORT AND EDUCATION TO THE SCHOOL'S STUDENTS AND FAMILIES.

(2006)

In 2006, TSD celebrated its sesquicentennial, marking 150 years of quality service to the state's deaf and hard-of-hearing students and their families. A series of celebrations were held across the campus, and a historic landmark marker was placed at the entrance to the campus on South Congress Avenue. (Author's collection.)

Students are pictured learning about cows in 1946 at the Texas School for the Deaf. TSD serves students kindergarten through post-secondary. It is a state-operated primary and secondary school for deaf children. Besides academics, TSD has always had vocational courses for a wide variety of trade and career preparation and has progressed in course offerings from agriculture, cosmetology, carpentry, home economics, and shoemaking to fine arts, auto-collision repair, child development, business information management, welding, and technical training in digital interactive media. (DM-46-C469.)

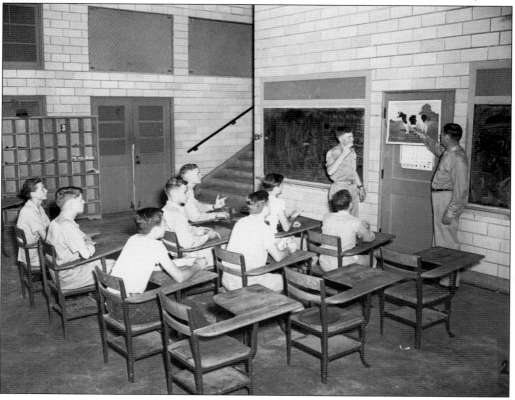

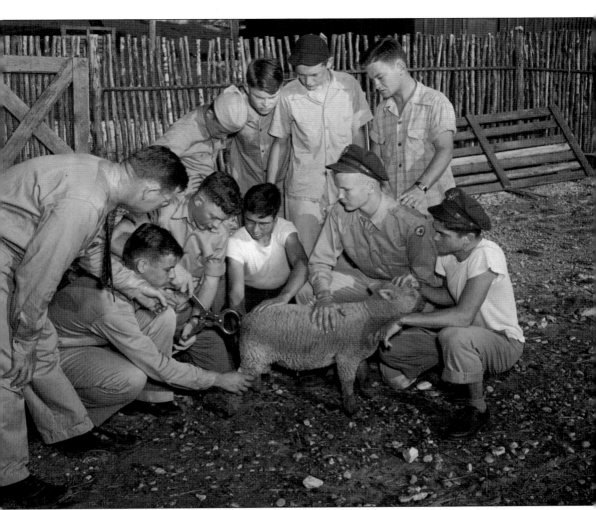

Texas School for the Deaf students are pictured in 1946 having hands-on education with sheep. On the back of this photograph is the following label: "Vocational Agriculture Class 1940s. Texas School for the Deaf. Jesse E. Fox Instructor." For many years, African American deaf children were educated at a separate west Austin facility at first, and then later in east Austin until the TSD student bodies were integrated in the fall of 1965. After that, the east Austin campus continued to be used for multihandicapped deaf students as well as early childhood and elementary students until 2001 when the campuses consolidated. All services now are handled by the South Congress Avenue location. (ASPL_DM_46-C471.)

Housing units at the Texas School for the Deaf are pictured in 1957. During the 1800s, many of the pupils' parents were too poor to afford to take them home during vacation, so they stayed at the school for several years. Some families moved to Austin to live there while their children attended the TSD. Today, students live on-site five days a week and go home for the weekends unless there is a school weekend activity requiring their presence. (ND-57-514(m)-01.)

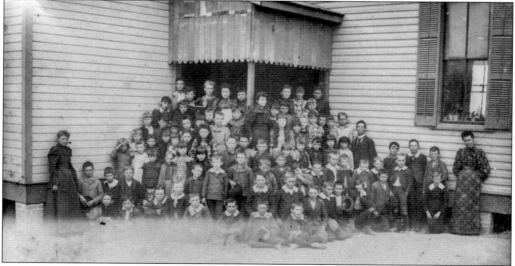

Fulmore School is pictured sometime between 1892 and 1898. Fulmore is located on South Congress Avenue and was founded in 1886 as a one-room white frame schoolhouse with a bell tower. In this first school, water come from a barrel that was filled at the Colorado River and covered with a gunny sack. (PICA 07649.)

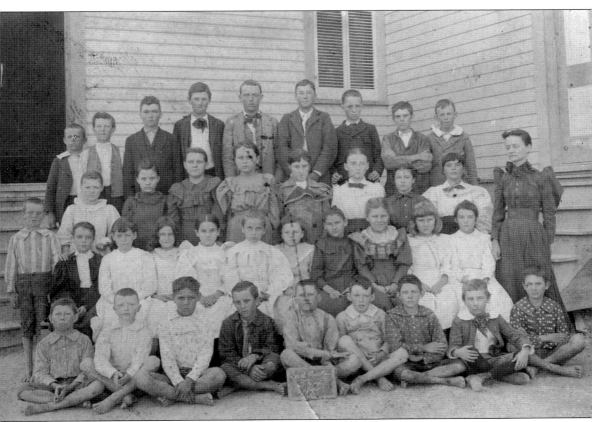

Fulmore School students are pictured in 1895. In 1911, a brick school building was constructed a block farther south to replace the earlier wood structure. The first teacher was Luetta Kinney, the daughter of the first principal of the nearby Texas School for the Deaf. In 1892, the school was named after Judge Zachary Taylor Fulmore. The original brick school is still in use today, but the school has been greatly enlarged around it over the years. Originally, Fulmore School served students in elementary and middle school. Those who wanted to go to high school had to go to Austin High School across the river. Today, Fulmore is a middle school with a well-regarded magnet program. (PICA 14149.)

The Fulmore School's 1911-constructed building is pictured in 1926. The front of the 1911 school is now incorporated into the remodeled school's library—taking up one of the library walls, a striking element. The entire original building can still be seen from surrounding streets, but it is overshadowed by Fulmore's building additions. (C03813.)

The Fulmore School bell has a rich history. It was given to the school by developer Charles Newning and was used to notify the neighborhood of the start and end of the school days. On the night before Thanksgiving 1911, pranksters from the University of Texas's B-Hall men's dormitory stole the Fulmore School bell. The university students were soon found out, partly due to the bell having a distinctive ring. After much pressure by Supt. A.N. McCallum, the B-Hall boys returned the bell to where it has stayed since. Sometimes, youngsters would toll the bell on Halloween and New Year's Eve, much to the annoyance of neighbors. (Author's collection.)

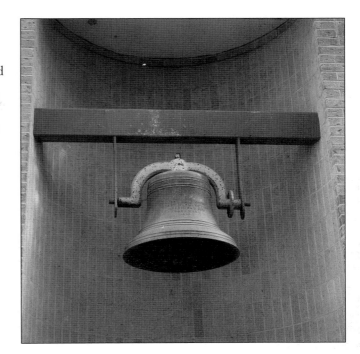

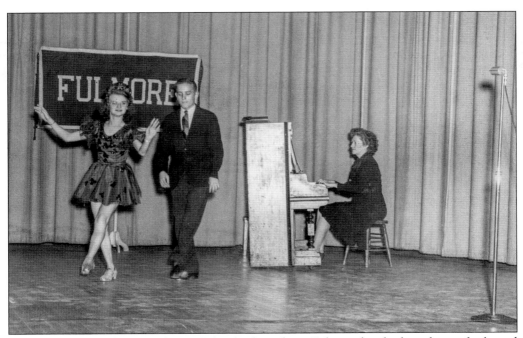

This is a moment from a Fulmore School talent show. Fulmore has had its share of talented students. Some of the well-known alumni from this school include folklorist John Henry Faulk, Margaret Gomez, and former Austin mayor Lee Leffingwell. Former Texas governor Ann Richards once taught at Fulmore. (PICA 22802.)

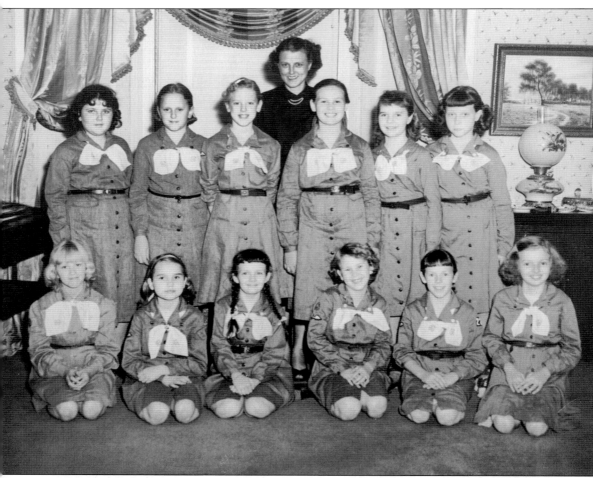

A Travis Heights Girl Scout troop poses in 1952. Ruthann Rushing attended this meeting during her third-grade year at the leaders' house. The residential streets in this area were dominated by young families at the time. South Austin grew dramatically when transportation improved years earlier, both with a bridge connecting north and south Austin and the intense promotion and development of Travis Heights. (Courtesy of Ruthann Rushing.)

Travis Heights Elementary School is pictured sometime shortly after the school was built in 1939. This school has had a great reputation in south Austin. Longtime Travis Heights former teacher and principal Bernice Kiker retired in 1970, and years later a school in the Circle C Development of far south Austin was named after her. In 1973, Travis Heights became a sixth-grade center. In 1980, Travis Heights once again became an elementary school. It celebrated its 75th anniversary in 2014. (PICA 26902.)

Students in the third-grade class of Marie Hinds are pictured at Travis Heights Elementary in 1950. The students and teacher are on the new steps leading outside from a recent addition. Ruthann Rushing remembers, as a student there, playing in the creek behind the school even with no fences around the borders of their playground. (Courtesy of Ruthann Rushing.)

This is an early photograph of William B. Travis High School, which opened in 1953. Located at 1211 East Oltorf Street at what was then the southern edge of the city, the school was named after the commanding officer of the Alamo. Notable alumni include former Austin mayor Lee Leffingwell and musicians Roky Erickson and Joel Reyes. (PICA 07582.)

Jane Smoot was a teacher at Travis High School from its opening until 1979. She had held other Austin school district teaching positions before Travis but was especially remembered at the high school. She was also active in civic and genealogy clubs in Austin, and her family was a vital part of Austin history. The elegant Smoot House was originally constructed in 1877 by Dr. R.K. Smoot, a Presbyterian minister. The house and surrounding grounds are currently managed by the Flower Hill Foundation, which is trying to open the house as a working museum. (Courtesy of the Flower Hill Foundation.)

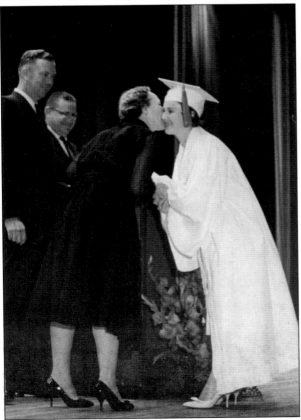

Ruthann Bray (Rushing) receives her diploma at Travis High School during the 1960 graduation ceremonies. Her mother, Garrie Bray, who was on the school board, is seen handing her the diploma. Buck Avery, also on the school board, stands by on the left. To the right of Avery is principal W.A. Sloan Jr. (Courtesy of Ruthann Rushing.)

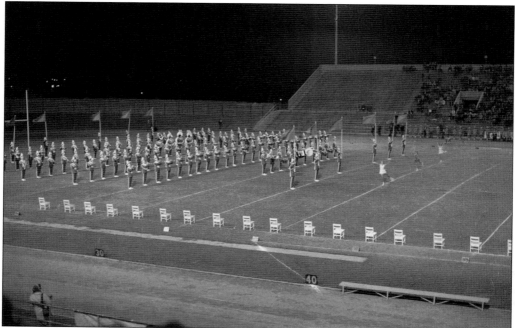

Travis marching band is on the field during a football game in 1974. Travis High School was the only high school in south Austin from 1953 until 1968, when Crockett High School was built farther south on Stassney and Manchaca Road. When Travis High School was built in 1953, Oltorf Street was a gravel road on the edge of town that dead-ended at the high school. (Courtesy of John Stewart.)

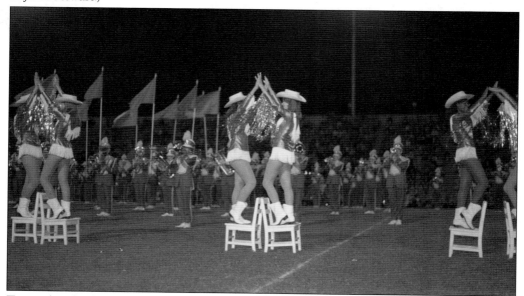

Travis cheerleaders perform their chair routine at a football game in 1974. Travis High School had some interesting traditions, like its "Hex Austin" pep rally with the cheerleaders and the student body to favorably influence the outcome of the upcoming football game against local powerhouse Stephen F. Austin High School. (Courtesy of John Stewart.)

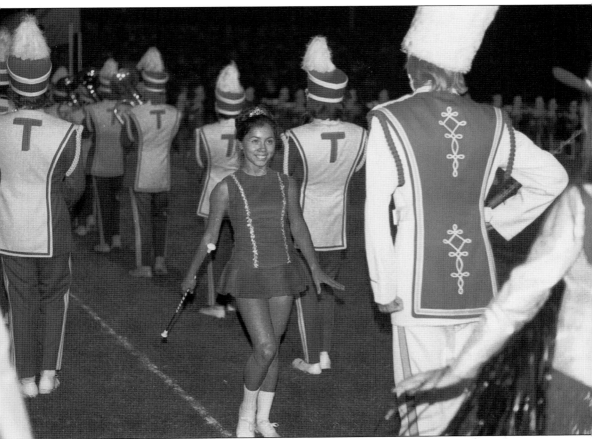

The 1974 Travis marching band commands the field on a game night. Baton twirler Shirley Sanchez is in the center, facing the camera. The 1974 Travis High School *Rebel Roundup* yearbook reports that the school had a successful football program and was no. 2 in the district, right after Reagan High School. The Travis marching band had approximately 115 members and three baton twirlers. (Courtesy of John Stewart.)

In June 1975, these 1965 former classmates pose at their 10-year reunion. Travis High School had been opened for 12 years, and the Congress Avenue Bridge sported a banner that read "Welcome to South Austin Home of the Fighting Rebels." This was especially meaningful in the years when Travis was the only south Austin high school. (PICA 07941.)

Travis High School sits within a couple of blocks from Interstate 35. This was the view looking north at that highway around the Travis Heights area in the 1960s. Ruthann Rushing remembers that kids would ride horses in this area before the interstate highway was built in the 1950s. Afterwards, residential and commercial development of lands south and east of Austin greatly increased as the city grew in all directions. (PICA 01315.)

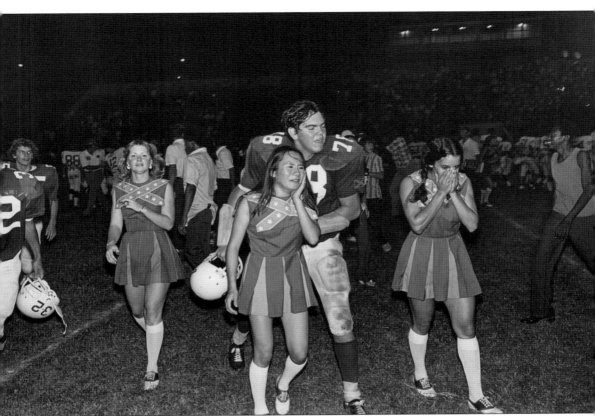

Emotions ran high at this 1975 Travis High School football game. Football has long been a major team sport in Texas. The games were and still are hugely important to the community. Also important was going to hang out with friends after the game. The 1975 *Rebel Roundup* yearbook holds student comments about how "it's just not cool if you don't go to Gatti's (Pizza) on Riverside Drive after the game." (Courtesy of Rick Patrick and the AHC [AR.2000.016(127)].)

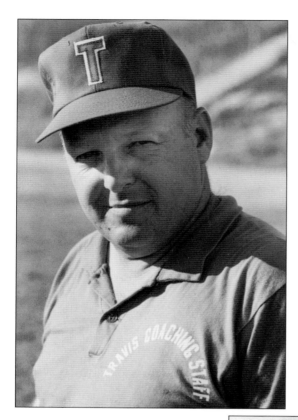

Travis High School coach Sonny Myers is pictured in 1971. Coach Myers served as an assistant coach at Travis High from 1955 through 1957, and in 1958 he became the head football coach. Sonny served as the head coach at Travis for 22 seasons, with successful seasons in the 1960s and 1970s as his teams won most of their games. (PICA 03776.)

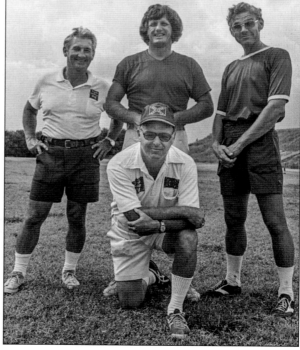

Four Travis High School coaches are pictured sometime in the 1970s. Kneeling in front is Coach Sonny Myers. In the back, from left to right, are Delbert Davis, Tommy Cox, and Charlie Roberts. Cox was quarterback in 1966, the year he graduated from Travis High School. He later coached at Travis, South San Antonio, Killeen, and James Bowie High Schools in Austin. Years later, Cox became athletic director for the Austin Independent School District, where he served until 2014. (PICA 10798.)

Four

COMMUNITY

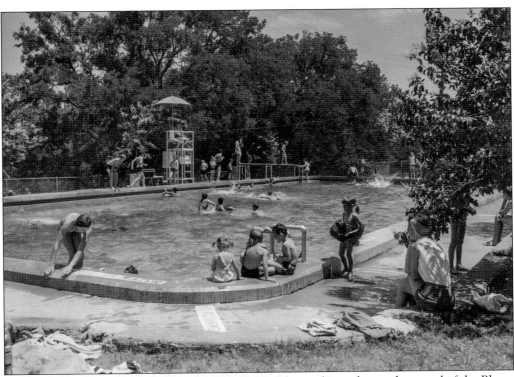

This is Austin's Stacy Park Pool in the early 1960s. The pool is at the southern end of the Blunn Creek greenbelt park inside the park area known as Big Stacy Park, which is located at 700 East Live Oak. This pool is open year-round, as its water is supplied partly by underground springs providing warmed water. A few blocks north, connected along the same creek and greenbelt trails are the Little Stacy Park recreational facilities and wading pool. Both pools were originally built in the 1930s and are still there today. Blunn Creek is named after Joe Blunn, an Englishman who came to Austin in the mid-1800s and advocated for a bridge over the creek. (PICA 21258.)

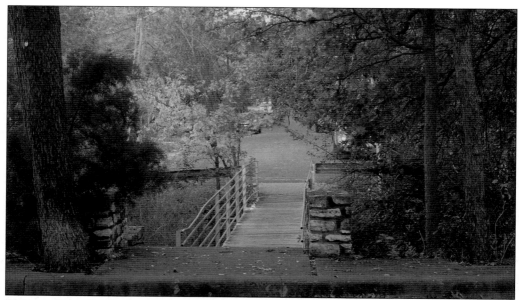

This small wooden bridge connects Alameda Drive to Pecan Grove Road. Austin residents who grew up in the neighborhood remember thinking of this bridge as a secret bridge because it is not easy to see unless one already know where to look. Area children ride their bikes across this narrow span, which is still in use today and connects to Little Stacy Park. (Author's collection.)

This is the Big Stacy Park parking lot on Live Oak Street. The rustic and small parking lot is along the rugged edges near Blunn Creek. Stacy Park was designed to be a major recreational area and serves as an informal divide between Travis Heights residential development to the east and the Fairview Park and Swisher Addition to the west. Newspaper articles from the 1930s describe Stacy Park as serving all south Austin as one of the largest and best-patronized playgrounds in Austin. (PICA 37865.)

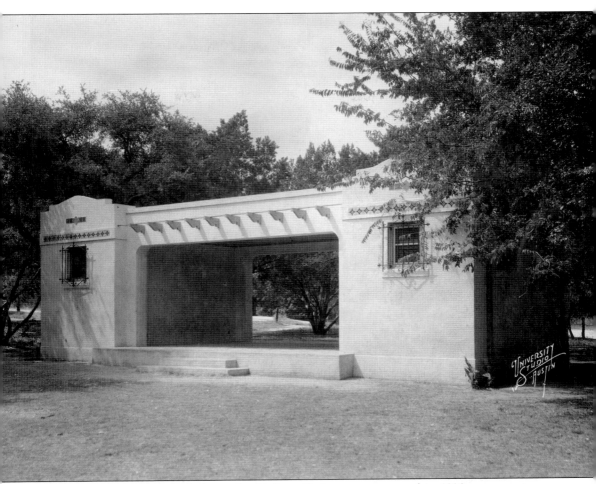

The Mission Revival–style shelter at Little Stacy Park was constructed in 1930 as a one-story stucco structure with two rooms and a flat roof. The breezeway between the two rooms has been used in the past for performances and games. It was designed to complement the architectural style of the neighborhood. Based on early photographs, Hugo Kuehne is attributed with having designed this and a few other park shelters in Austin. Kuehne was on the parks board, and he founded the University of Texas School of Architecture. (PICA 25456.)

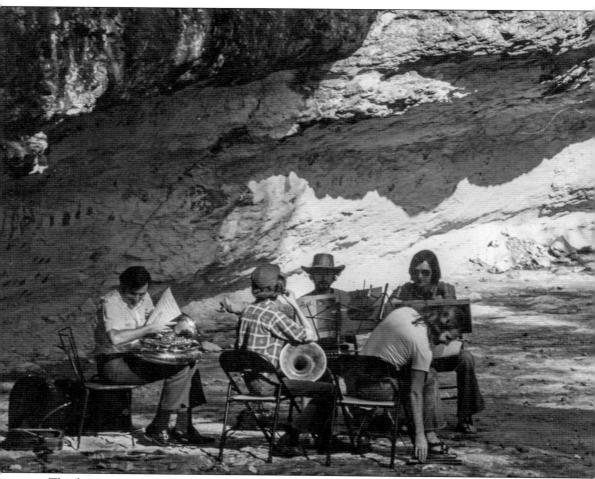

This happening took place along Blunn Creek in the fall of 1973. Blunn Creek weaves its way, meandering along the landscape in the Travis Heights neighborhood. The greenbelt travels the length of the neighborhood. The north end of the neighborhood is capped by the Norwood Tract Metropolitan Park. The Norwood Tract was labeled as Travis Park on maps 100 years ago. (PICA 27478.)

The Circle Greenbelt runs parallel to the Blunn Creek Greenbelt and connects to The Circle street on its south side and to Academy Drive on its north end. It seems to be along the path that the original development plat map indicates it would have been a section of the street named The Circle. The creek within this narrow sliver of a park frequently floods during rains. (Author's collection.)

Pictured here is the bridge over the creek behind Travis Heights Elementary School. In the early days of the school, this wooden bridge was used by parents to drop off and pick up their children behind the school. In 2018, the bridge remains accessible for pedestrians but has been blockaded to prevent vehicles from entering onto it. (Author's collection.)

The South Austin Island park sits along South Congress Avenue and East Live Oak Street. A 1939 *Austin American-Statesman* newspaper article mentions that some citizens and city leaders were discussing the idea of having a traffic island at that exact intersection for an emergency safe place for children and other pedestrians trying to cross the busy intersection to reach the brand-new Austin Theatre at the junction. At that time, the intersection had a lot of traffic, as South Congress was the main gateway into Austin from the south. (Author's collection.)

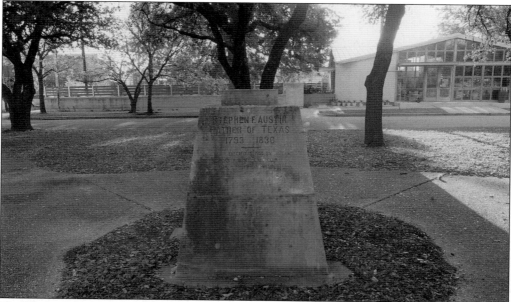

This is the foundation for the Stephen F. Austin sculpture that used to stand in South Austin Island Park. The statue was created by Ira A. Correll and placed in this park in 1955. It was smashed by vandals in 1991, and now just the sculpture base remains. The engraving on it reads, "Stephen F. Austin, Father of Texas 1793–1836." The sculpture was given to the City of Austin with the provision that it be placed where visitors passing through the city could easily view it. (Author's collection.)

Faith Presbyterian Church at 1314 East Oltorf Street is pictured in 1972. This church formed in 1957 and held its first meeting in the cafetorium of William B. Travis High School until a permanent church was built just across Oltorf Street. The first pastor was Rev. George Sullivan. He and his family had moved into the manse just acquired by the presbytery and located on Sylvan Lane in nearby Woodland Hills. (PICA 03555.)

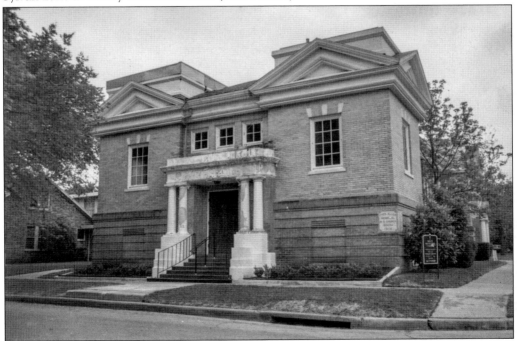

Grace United Methodist Church at 205 East Monroe Street is pictured in 1967. Established in 1897, the congregation built its first church building on West Johanna near Wilson Street. The cornerstone from that site was incorporated into the present site in 1914, along with some building materials from the first church. Its name was changed to Fred Allen Memorial Methodist Church. In 1968, it became Grace United Methodist Church. (PICA 03497.)

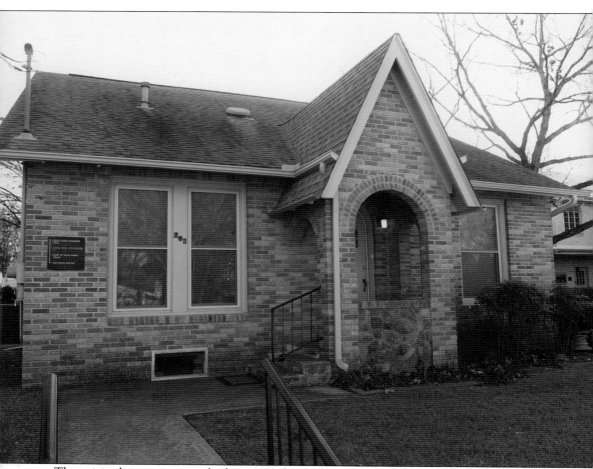

The original parsonage was built in 1922 for the same Methodist church seen in the previous photograph. The parsonage would have been used as the home for the minister. It was built when the church was known as Fred Allen Memorial Church. In 2015, Grace United Methodist Church became Life in the City Church. The former parsonage is used for church offices. (Author's collection.)

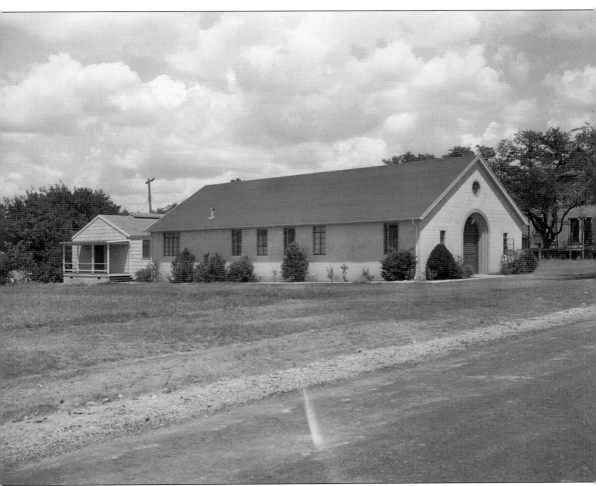

South Austin Christian Church is pictured in 1950 at 206 East Annie Street. This church opened in 1947. One hundred years after the Christian church first laid its foundation in north Austin, this south Austin church opened at East Annie and Nickerson Streets. At the opening of the church, Rev. O.E. Grimes, minister of First Street Christian Church, delivered the invocation. (ND-50-238-01.)

South Austin Baptist Church is pictured in 1957, when it was newly built at 517 East Oltorf Street. This church had originally begun with a few families and services held in a washeteria. The church grew to a membership of more than 500 by 1973, when they were celebrating the 10th anniversary of their pastor, Rev. Patrick Everitt. This church relocated farther south in 1984, and now the Oltorf site is the home of the Life Tabernacle Church. (ND-57-305-01.)

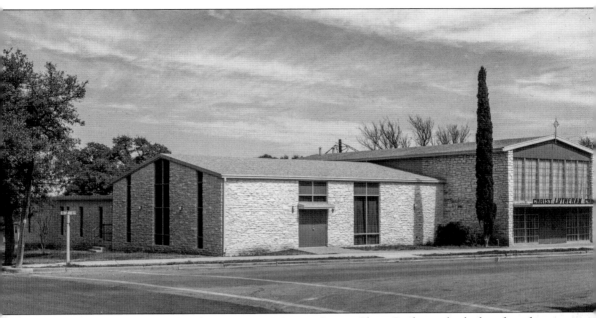

This is Christ Lutheran Church at 300 East Monroe Street. Christ Lutheran built this chapel in 1946 and, before that, held services in a house at 212 East Monroe Street. The 1946 chapel was designed by well-known architects Arthur Fehr and Charles Granger. (PICA 00539.)

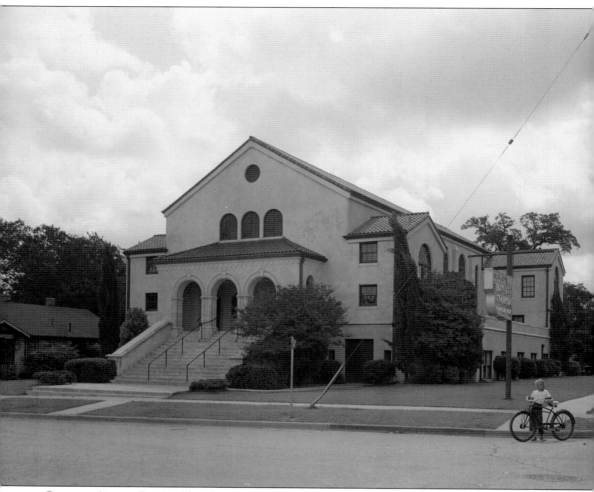

Congress Avenue Baptist Church is pictured at 1511 South Congress Avenue in 1947. This church was started in 1891 when 4 men and 10 women started meeting in Fulmore School and formulated a plan. Charles Newning donated property, and the first building went up on Brackenridge Street in 1894. In 1925, the church was established at the present location of 1501 South Congress Avenue at the site of a former motel. The ground breaking for the newest sanctuary was in 1966. In 2018, the church is called the Church on Congress Avenue. (ND-47-170-01.)

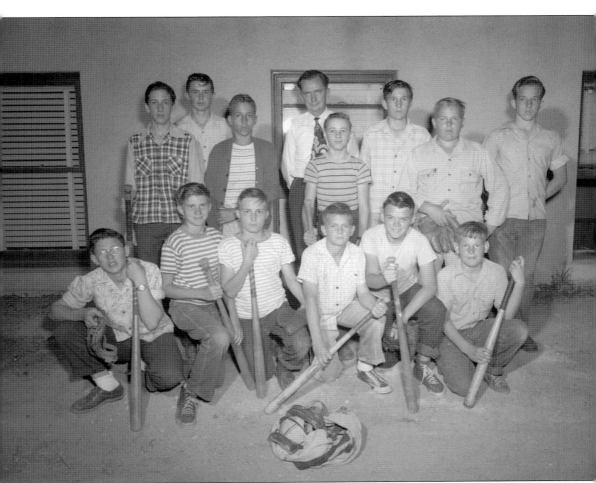

Members of the Congress Avenue Baptist Church boys' baseball team are pictured in 1948. This church has a long history and a large property in the neighborhood as well as a significant presence in various ministries for youth, including sports. The church's own elementary center on the north end of the property was once a motel that the church purchased in 1965 and was extensively remodeled and refurnished. (ASPL_DM-48-C2737.)

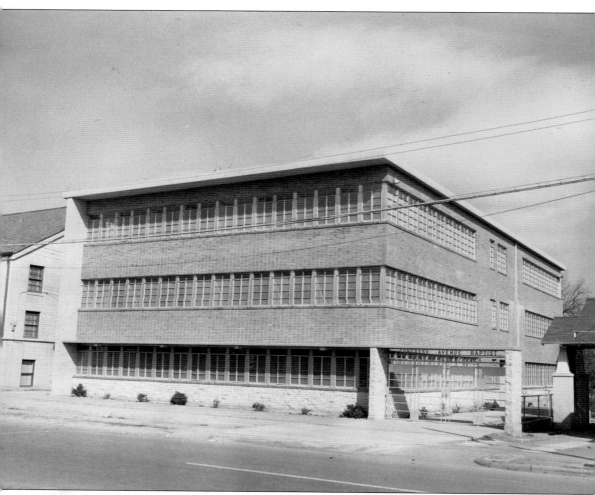

Congress Avenue Baptist Church Education Building is pictured in 1951. The church grew rapidly and, by 1966, when it celebrated its 75th anniversary, had become the sole owner of the entire block. The church also had a ministry to Austin's deaf population that may have comprised as much as 25 percent of the church membership. This church is also geographically close to the Texas School for the Deaf. There were always deaf people living in Fairview Park and Travis Heights, especially noticeable from the 1900s to the 1950s. (ND-51-242-02.)

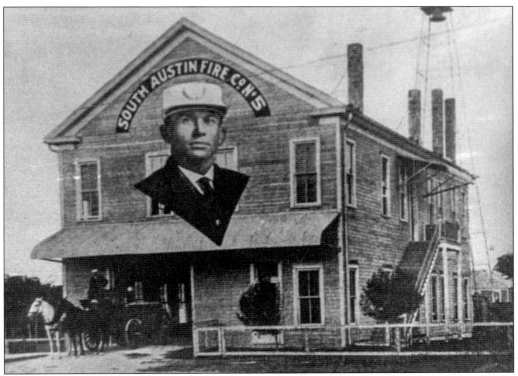

South Austin Hose Co. No. 5, established in 1895, is pictured with Claude Wright the driver. There was a fire station at 1315 South Congress Avenue, which places it where today the Continental Club is now located. The hose company's motto was "To the Rescue!" This served as the only fire station in south Austin until Fire Station No. 11 was built in 1949. (PICA 00172.)

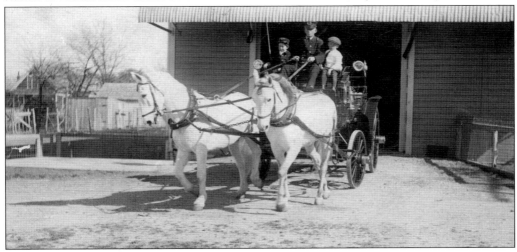

A close-up shows the Volunteer South Austin Hose Company and unidentified wagon occupants. Horse-drawn wagons were used in the days before fire trucks. In 1916, city of Austin voters approved the establishment of a fire department with fully paid personnel. The volunteer fire companies were disbanded, and the fire department had to renumber fire stations and rename its apparatus. South Austin No. 5 became Engine No. 6 at Fire Station No. 6. (PICA 38133.)

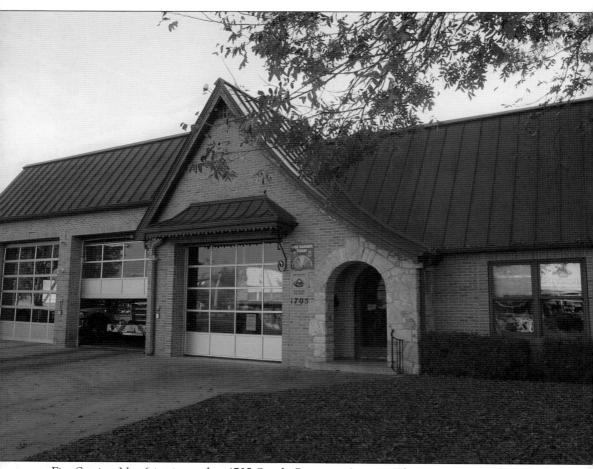

Fire Station No. 6 is pictured at 1705 South Congress Avenue. This station opened in 1932 to replace the previous wood structure at 1315 South Congress Avenue that had been built in 1895 to house the South Austin Fire Company. In 2018, this fire station is still in use in the middle of the thriving commercial district of South Congress Avenue. (Author's collection.)

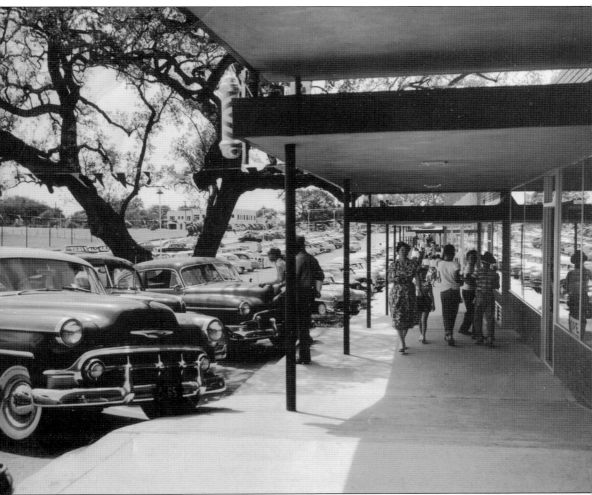

Twin Oaks Shopping Center was opened in 1953 and named after a pair of trees on the property, but it was more than just a shopping center. It was also a community centerpiece providing a wide range of services and stores. It was a popular destination for both south Austin residents and Bergstrom Air Force Base personnel. What is most remarkable about this photograph is that it shows the lack of development across the street, which would be the southside of Oltorf Street. In the distant background, it seems possible to see Kinman Tourist Courts beside South Congress Avenue. (Courtesy of Joe Jung.)

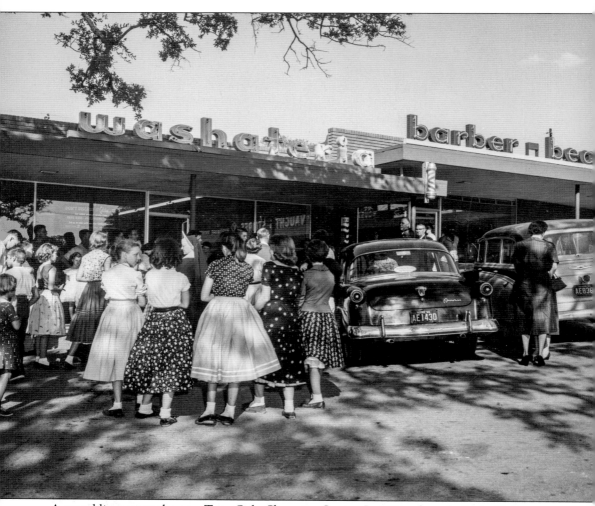

A crowd lines up at the new Twin Oaks Shopping Center. In 1974, when the Twin Oaks center was celebrating its 20th anniversary, it listed tenants such as Luby's Cafeteria, Slax, Fashion Shops, Elizabeth's Jewelry, Mode O' Day, Winn's, Twin Oaks Camera Shop, Southern Maid Donuts, Miles Hardware, the Fabric Shop, Twin Oaks Cleaners, Twin Oaks Florist, Twin Oaks Barbershop, and the Twin Oaks Library. (PICA 01545.)

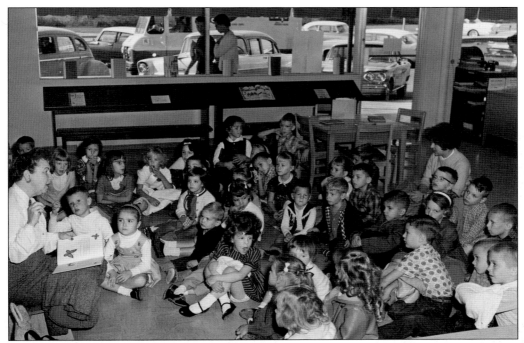

It is story time at the Twin Oaks Library. The library was located at this shopping center for over 50 years before finally being relocated to a dedicated building at the corner of South Fifth Street and West Mary Street. The new Twin Oaks Library was opened in 2010 where the South Austin Post Office had once been. (PICA 13662.)

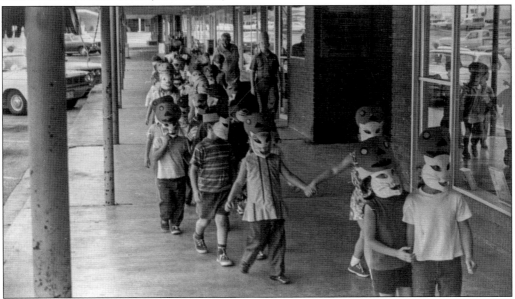

Children celebrate Halloween at the Twin Oaks Library in 1971. They are lined up at the Twin Oaks Center outside of the storefronts, wearing handmade paper masks. The stretch of storefronts in the photograph appears to be along the south side of the center that faces Oltorf Street. (PICA 28178.)

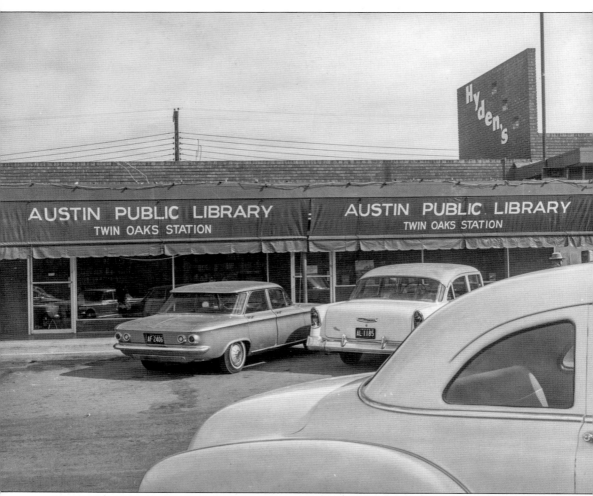

Pictured in 1962 are the Twin Oaks Library and the sign for Hyden's grocery store next door at the Twin Oaks Shopping Center. Advertisements for Hyden Groceries and other Twin Oaks shops are in the sponsor pages of vintage William B. Travis High School yearbooks. Joe Jung, of the family that originally owned the Twin Oaks, recently recalled an unlikely incident many years ago when there were just two other shopping centers in Austin like Twin Oaks: Allandale and Delwood, and the Delwood and Twin Oaks maintenance men had a traffic accident with each other in their maintenance trucks. What are the odds that those two would cross paths literally and have a collision? Most of the stores are gone now, some of them leaving quickly after the new owner, HEB, purchased the center in 2016. (PICA 13665.)

Five

BUSINESS

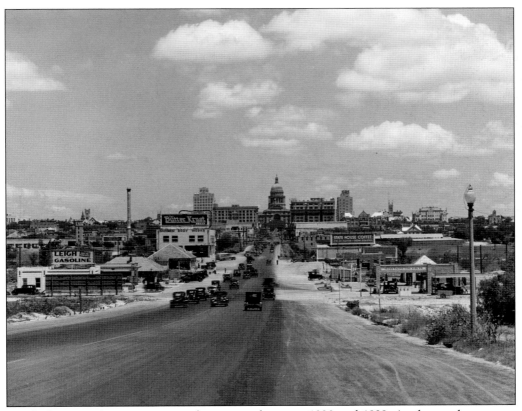

South Congress Avenue is pictured sometime between 1920 and 1939. As the southern entry into the city, South Congress Avenue attracted business catering to travelers, including gas and service stations, restaurants, and tourist accommodations. The left side of this photograph shows Southwest Body Works with a Butter Krust bakery advertisement sign on top and the Night Hawk restaurant in front of it. (C00622.)

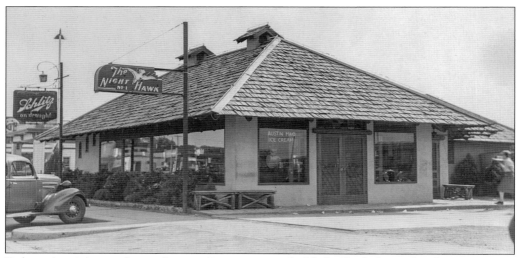

Perhaps Austin's most famous historic restaurant was the Night Hawk, located at the intersection of South Congress Avenue and Riverside Drive and pictured here in 1932. Harry Akin opened this restaurant where once there had been an abandoned fruit stand at 336 South Congress Avenue. The Night Hawk opened as a hamburger restaurant. This restaurant had to be extensively repaired at least two times following major flooding before the Colorado River dams were finished. This restaurant closed in 1985, and now a title company operates out of the building. (PICA 28690.)

Night Hawk customers are pictured at the counter in the 1930s. Over time, the Night Hawk expanded from serving hamburgers into a restaurant with a more refined atmosphere and a broader menu, including steaks. It was widely popular, and several Night Hawk restaurants were opened in other locations around Austin. Harry Akin also went on to create a line of frozen dinners that packaged Night Hawk's unique chopped steak meal. (Studer Photography and AHC [PICA 28697].)

Harry Akin, always an active Austin citizen, became the mayor of Austin from 1967 to 1969. He is shown here in 1958 during a rare relaxed candid moment. The Night Hawk restaurant was an informal meeting place for politicians and business leaders who met over steak and coffee. A January 26, 2001, *Austin Chronicle* article mentions that when Gov. John Connally walked into the restaurant, after being wounded in the Kennedy assassination, everyone in the restaurant stood up silently in respect. Harry Akin died in 1976, and all but one of his restaurants had closed by 2018. The frozen dinner line is still carried in some grocery stores. (ND-58-323-01.)

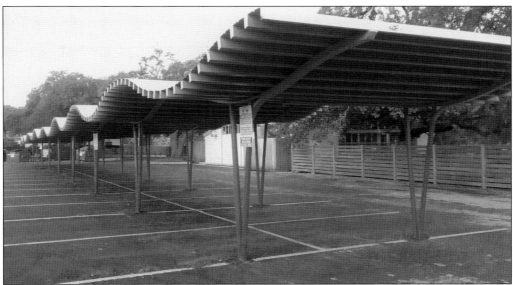

This is the wavy parking cover from Austin's Pig Stand restaurant at 2201 College Avenue. The Pig Stand was there from the late 1950s until the late 1970s. The Pig Stand is gone, but the eye-catching parking cover still stands and gets used today for people parking at the Vinaigrette restaurant that now sits in the same location. The poles for the Pig Stand elevated sign also still stand. The massive live oak in the patio could be one of the oldest in south Austin. City of Austin directories list a Pig Stand restaurant in south Austin in the early 1930s along South Congress Avenue closer to the Colorado River. After the mid-1930s, it disappears from the city directories until it reappears in the 1950s at the College Avenue site. The Pig Stand franchise started in the Dallas area and was eventually all over the United States. All the locations have closed now except perhaps for one in San Antonio. The Pig Stand is credited for having popularized many fast-food staples, including deep-fried onion rings, chicken-fried steak sandwiches, and Texas toast. (Author's collection.)

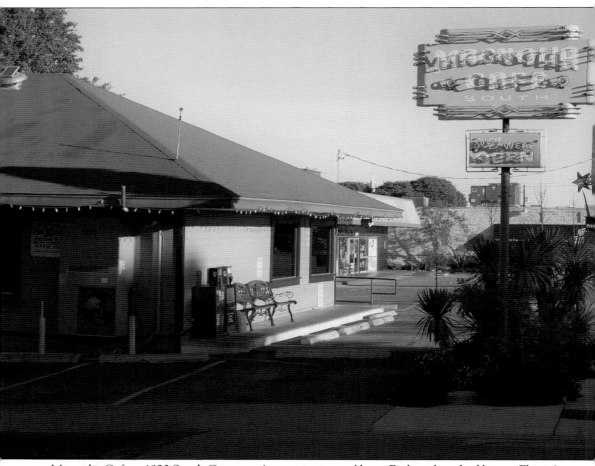

Magnolia Cafe at 1920 South Congress Avenue is pictured here. Earlier, there had been a Flossie's Drive-In at this site for several decades. Magnolia opened in 1988 when the Magnolia Cafe in west Austin expanded onto South Congress Avenue. The two Magnolia Cafes share some common history with Austin's Kerbey Lane and Omeletrry restaurants and all are still in operation today. (Author's collection.)

Hudson's Fine Meats advertised in the mid-1970s as a meat shop. It had available for sale every type of meat that is normally purchased at a butcher shop or in a grocery store today. Located at 1800 South Congress Avenue, the company is still in business, primarily processing deer meat. (Author's collection.)

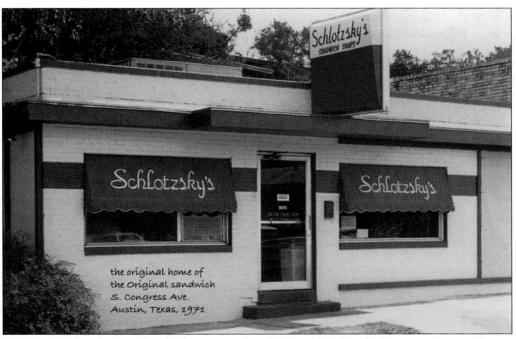

The first Schlotzsky's sandwich shop opened in 1971 at 1301 South Congress Avenue. It was successful there and expanded to other sites. The Schlotzsky's franchise grew rapidly and went on to become a national chain that is now headquartered in Atlanta, Georgia. In 2018, its original building houses an Amy's Ice Cream. (Courtesy of Schlotzsky's Corporation.)

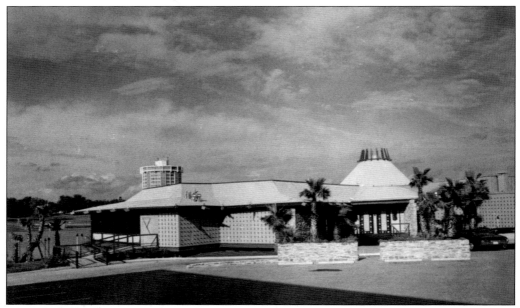

The Steak Island, pictured here in 1971, was at 600 Riverside Drive from the late 1960s until the mid-1970s. Steak Island had a Polynesian theme during the time when the tiki trend was popular in the United States. From the thatched roof to the sarong-clad waitresses, the theme was exotic—even if the food served was primarily steaks and seafood. Steak Island was known to be a favorite restaurant of Lyndon Baines Johnson's when he was in town. (PICA 05832.)

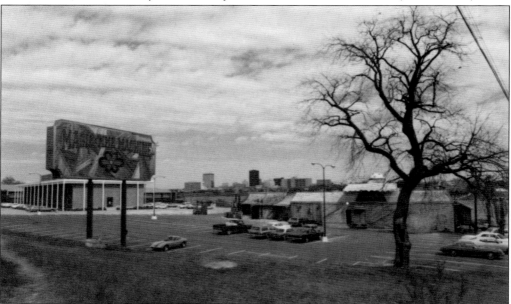

The Magic Time Machine restaurant, pictured in 1976, replaced Steak Island at 600 Riverside Drive. This restaurant featured a time travel theme. Its unusual décor included a soup-and-salad bar that was built inside a small convertible car. When it opened by the late 1970s, it had a disco dance floor along with its nostalgic theme. It closed in the 1990s, and there is now a Joe's Crab Shack in that location. (PICA 11050.)

The Continental Club has been located on 1315 South Congress Avenue since 1955. It started out as a swanky supper club. It became Austin's first burlesque club after that, and by the late 1970s was a live music venue. The Continental Club is now a historical landmark and is still well known as a popular venue for roots rock, traditional country and blues, rockabilly, and garage rock. (Author's collection.)

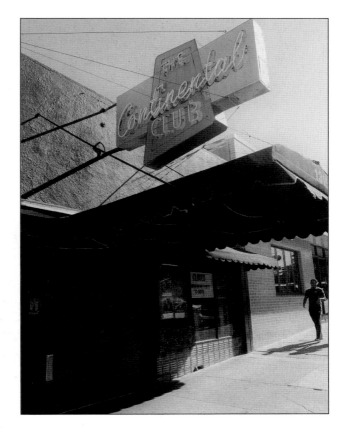

McNamara's was located at 506 South Congress Avenue and was known for selling bakery items and groceries as well as meals from its lean-to. It was also known for its birthday party events at the Austin Theatre in the 1940s through the early 1950s. McNamara's had large advertisements in the *Austin American-Statesman* newspaper that included details such as the price of a fried chicken dinner: 60¢. Roast beef and barbecue dinners were 50¢, and a roast turkey dinner cost $1. (Courtesy of the *Austin American-Statesman*.)

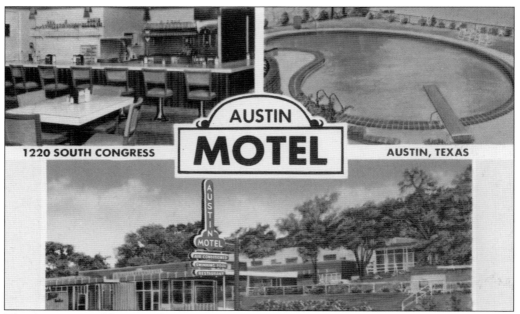

The Austin Motel has stood at 1220 South Congress Avenue from the 1930s until today. A daughter of the original owners of the 1200 block of South Congress Avenue opened the motel. It had opened when tourist accommodations were starting to blanket the area. South Congress Avenue was the major route into Austin from the south along the San Antonio Highway, or US Highway 81. As more people took to the road and cars became widely available, all kinds of tourist camps, motels, and motor hotels sprang up along South Congress Avenue. Some of them were Riverside Tourist Camp, Imperial 400, Terrace Motor Hotel, the San Jose Tourist Court, Riley Tourist Court, Royal Courts, the Kinman Tourist Court, the Acorn, the Sam Houston, Lacy Court Tourist Camp, Bohl's Tourist Camp, Don-Mar Court, and TV Motel. When South Congress Avenue started to decline, after the building of Interstate 35 near the eastern edge of south Austin, business for the Austin Motel also declined. (AF-P6150(26)-004.)

Pictured here are the famous Austin Motel's original neon sign and a poolside table umbrella. The motel has been maintained, and it looks like it is from a past time. The Austin Motel has recovered well from a period of decline during the 1970s through the 1990s. Now, it is a trendy destination motel. The Austin Motel is a unique little home-grown business that opened in 1938 and continues to operate after more than 65 years. (Courtesy of the Austin Motel.)

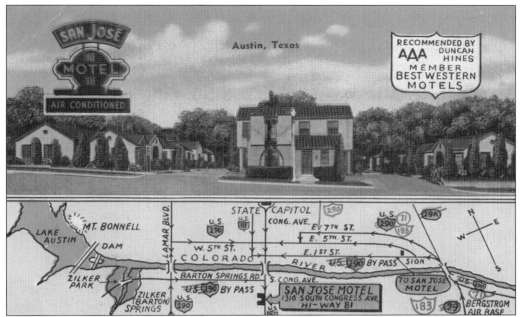

The San Jose Motel is located at 1316 South Congress Avenue. This early postcard shows a depiction of this historic inn along with a map. Originally built in the 1930s, it was a run-down relic by the time it was restored and refashioned into a posh boutique hotel in the early 2000s. This rebirth of the San Jose helped South Congress Avenue to attract more people back to the area. It is now the centerpiece of a strip of successful businesses along the western boundary of this neighborhood. (AF-P6150(26)-002.)

The Kinman Tourist Courts were once located at 2400 South Congress Avenue. But by the late 1950s, HEB and a strip mall had this address. The strip mall had several stores, including Kress, Walgreens, Western Auto, Radio Shack, and Franklin's Dress Shop. HEB has since been remodeled into a larger space. Eventually, the entire strip mall was engulfed by the successful and very busy HEB store. (PICH 07339.)

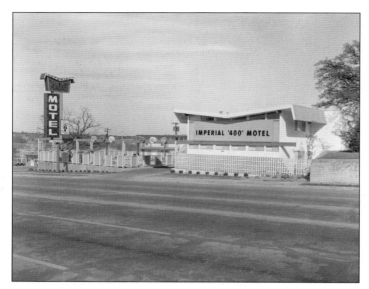

Pictured in 1961 is the Imperial 400 Motel at 901 South Congress Avenue. The Imperial 400 operated on South Congress Avenue from 1961 to the 1980s. The Austin site was one of many for this Southern California chain that expanded rapidly in mostly Western states. The distinctive architecture of the buildings is considered Southern California Mid-Century Modern. This motel was demolished not long after it closed. (ND-62-164-01.)

This 1961 photograph of the newly opened Imperial 400 Motel shows Ray Sackett and Patricia Sackett, who were the local owners. Also pictured are promotional bathing-beauty contestants, such as Miss Imperial 400 of Austin and her court of "bonnie mermaids." The grand opening advertisement also mentions the modern facilities, luxurious swimming pool, and that every room has a tub, shower, and telephone. (ND-61-328-01.)

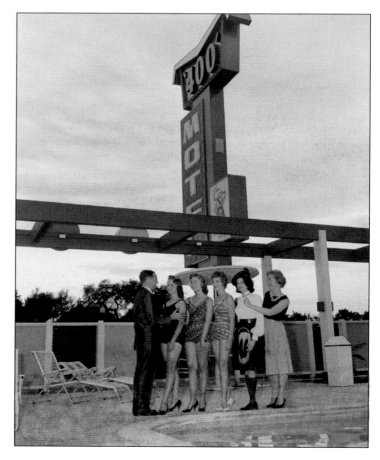

This is an exterior view of a Terrace Motor Hotel building in 1952. Located on South Congress Avenue along Academy Drive, the stylish Terrace had numerous multistory buildings over a terraced hilly area with beautiful landscaping. Over the next 15 years, it expanded at its South Congress Avenue and Academy Drive site. When fully built up, it was said to be a 366-room hotel that featured fine restaurants, two swimming pools, and a convention center. (ASPL_DM-52-C14824.)

This is an exterior view of the Terrace Motor Hotel entrance in 1952. The Terrace had a front office at 1201 South Congress Avenue. The buildings were variations of Mid-Century Modern style. The hotel was comprised of a collection of many individual buildings. Some of the buildings had striking triangular eaves with large expanses of plate glass. (ASPL_DM-52-C14840.)

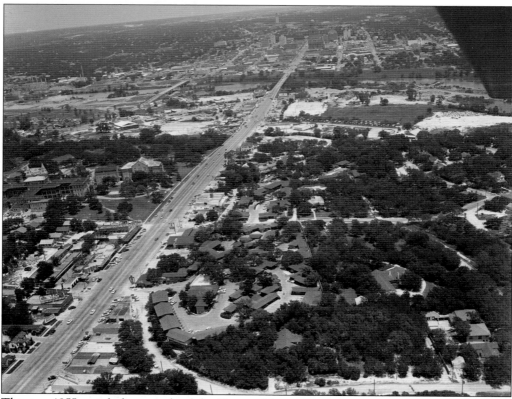

This is a 1955 aerial photograph of the Terrace Motor Hotel. It was spread out over Academy Drive, partially facing South Congress Avenue. The size of the entire property is easier to see in an aerial photograph. The entire hotel was called a motor hotel, and guests could drive up to the individual cottages. The entire complex spread out over the hilly terrain, both on the north side and on the south side of Academy Drive and along South Congress Avenue. The Terrace was advertised in 1960 as the largest motor hotel in Texas. Sixty years later, the Terrace complex has been torn down on the southern side of Academy Drive where the Statehouse Condominiums are now located. Most of the Terrace suite buildings on the north side of Academy Drive were torn down in late 2017 and are expected to be replaced soon by a new boutique hotel. The former Terrace convention center is now home to a software company, and a recording studio occupies the former site of the Terrace's Summer House restaurant. (ND-55-A-123-02.)

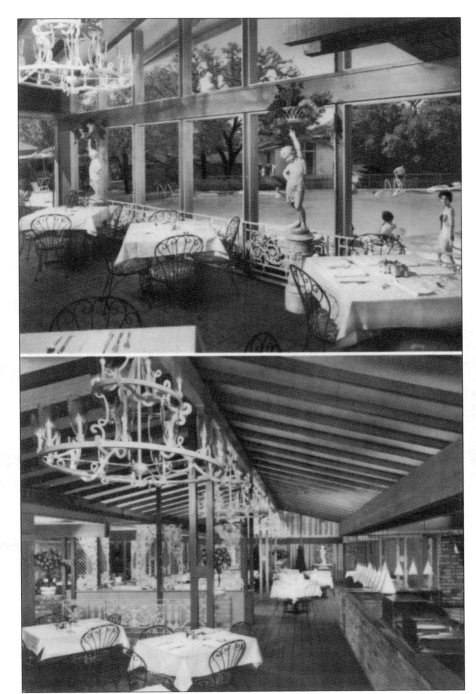

The Summer House Restaurant replaced the Charcoal Chef, a steak house, at the Terrace Motor Hotel, as featured in this undated postcard. The back of the postcard mentions that the Terrace Motor Hotel is truly one of the Southwest's finest resort and convention hotels. In addition to the guest rooms, restaurant, swimming pools, and office, there was a coffee shop, a barbershop with a singing barber, a beauty shop, and a nightclub. (AF-P6150(26)-003.)

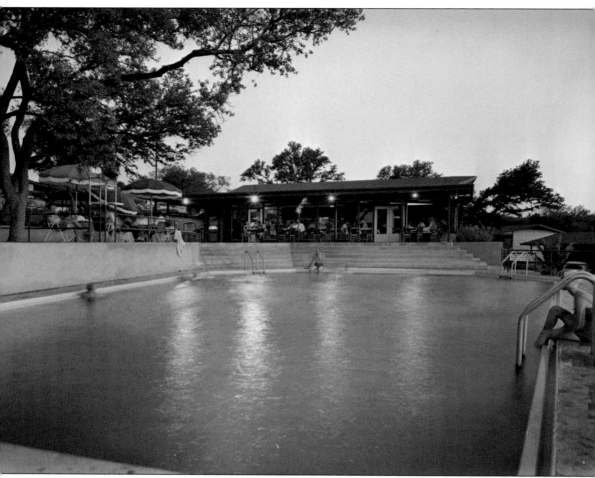

This is one of the two swimming pools at the Terrace Motor Hotel, pictured in 1952. The nearby Summer House was a poolside restaurant with an upscale atmosphere. There was a glass foyer that made the most of natural light, and the restaurant is said to have had a beautiful entryway The Terrace Motor Hotel was built by Dude McCandless, who also built the Villa Capri by the University of Texas. During its time, the Terrace was a destination hotel for celebrities visiting Austin. Dan Blocker, James Cagney, Sandra Dee, Jerry Lee Lewis, and others stayed there. (ASPL_DM-52-C14825.)

A Terrace Motor Hotel bellhop is pictured in 1958. The bellhops drove around in Jeeps to the different buildings. On the back of each Jeep was the sign "Follow Me," so the guests could follow the bellhops to their cottages. Unfortunately, the Terrace Motor Hotel declined in the early 1970s, like much of South Congress Avenue. The Terrace Motor Hotel was a motor hotel from 1951 to the early 1970s and then became part motel and part apartments. By the mid-1970s, all of the buildings had been converted to apartments. (ND-58-4532D-01.)

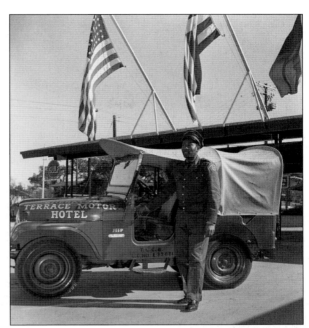

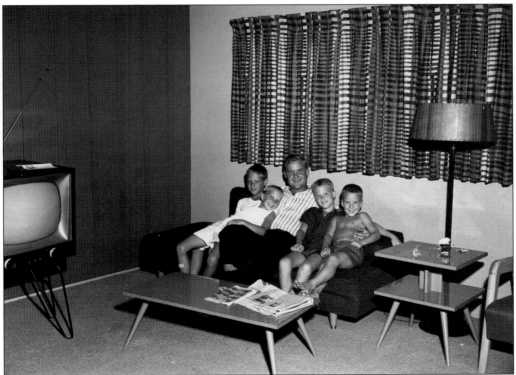

A family is pictured in one of the rooms of the Terrace Motor Hotel after the Sheraton Corporation took over in 1958. The Terrace convention center was close to the newly built municipal auditorium. While it may have been built for conventions and business, it also had family-friendly large suites available. (ND-58-453B-01.)

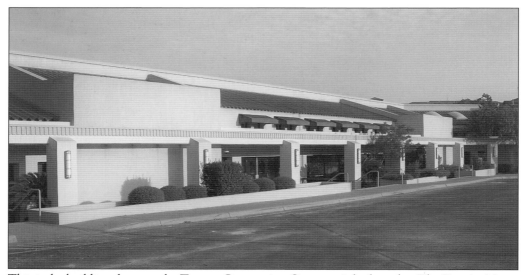

This is the building that was the Terrace Convention Center as it looks today. The Terrace Motor Hotel Convention Center was well suited for music performances, and one of the first concerts held there was for the Cowsills. After the motor hotel business ceased, the convention center first became the Texas Opry House, which closed in 1974. It reopened later as the Austin Opry House, which had a lot of comfortable amenities, such as a paved parking lot, air-conditioning, a large professional kitchen, and other attractive qualities that made it competition for another live music venue, the Armadillo World Headquarters, operating just a mile away. Some Austin residents remember a time when they could go to the Opry House, the Soap Creek Saloon, and the Continental Club, and they were all within walking distance of each other. In 1977, the *Austin American-Statesman* newspaper reported that the entire Terrace complex—clubs, parking, and apartments—was bought by Willie Nelson and his partner Tim O'Connor. In the following years, the apartments were often rented by musicians as well as other people. The Opry House remained a live music venue until it closed in the 1990s. It was then known for hosting the Armadillo Christmas Bazaar for years. Today, the former convention center houses Software Advice Company. (Author's collection.)

This photograph shows the north end of the Terrace Convention Center, including the attached Summer House restaurant that became Arlyn Recording Studio. Willie Nelson's nephew Freddie Fletcher is an owner of the studio. Freddy's mother is Bobbie Nelson, who played piano at the Terrace Summer House restaurant and later joined her brother's band. (Author's collection.)

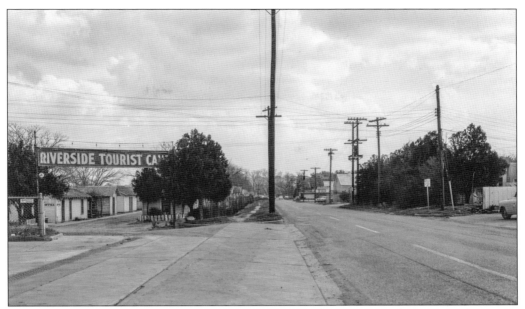

On the left side is the Riverside Tourist Camp that opened at 343½ South Congress Avenue in 1927 with 17 cottages at first. More cottages were added over time. This tourist camp advertised itself as having a modern bathhouse and parking spaces, being a short distance from the river, and that it was on the main highway from Austin to San Antonio. It was gone by late 1950s. On the right side of the photograph is Riverside Drive, heading east. (PICA 26884.)

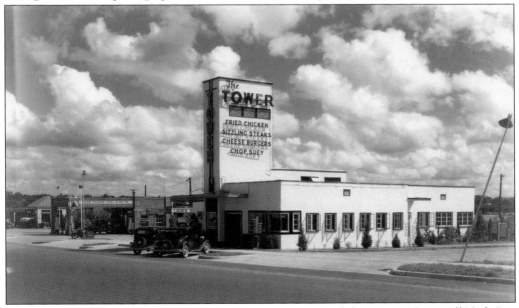

The Tower restaurant at 311 South Congress Avenue advertised that it was "Open All Night" in 1936. The Tower encompassed the restaurant shown and a bowling alley. In 1958, the well-liked Tower manager terminated his lease after 20 years in the business. This was the end of an era. Since the 1940s, many UT and high school students, Austin civic clubs, and religious groups had made the landmark their quasi-headquarters. (PICA 02557.)

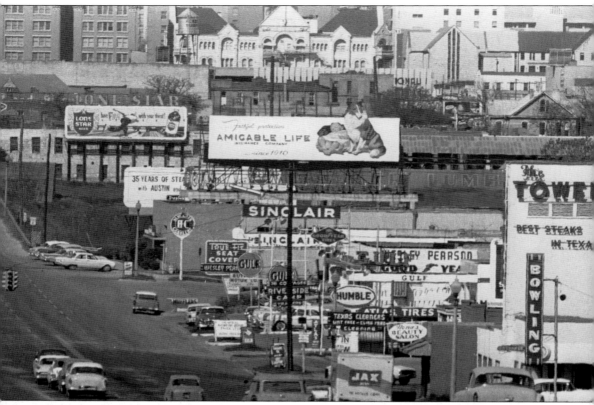

This c. 1961 view of South Congress Avenue is looking north near Riverside Drive. There are quite a number of roadside signs. On the right side, the Tower restaurant sign advertises "Best Steaks in Texas" and that it is "Open All Night." The sign for the Riverside Tourist Camp is also visible. Today, there is a Wells Fargo bank at this location, with a strip mall behind the bank. (Courtesy of the *Austin American-Statesman* and the AHC [AS-61-31073-8]].)

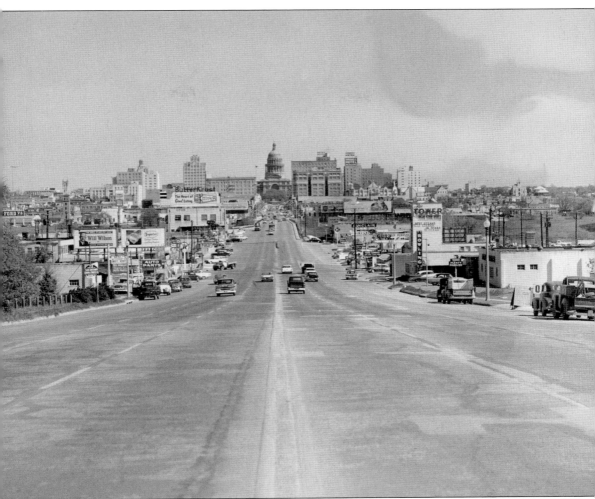

The view in this photograph is looking north along South Congress Avenue in 1961. Just a few blocks south of Riverside Drive, the South Congress Avenue clutter is less visible. Clearly in view are the Tropic Shop building, the Tower, and the capitol. The Norwood tower is to the left of the capitol. The most striking feature overall is the lack of tall buildings in downtown Austin. (PICA 01772.)

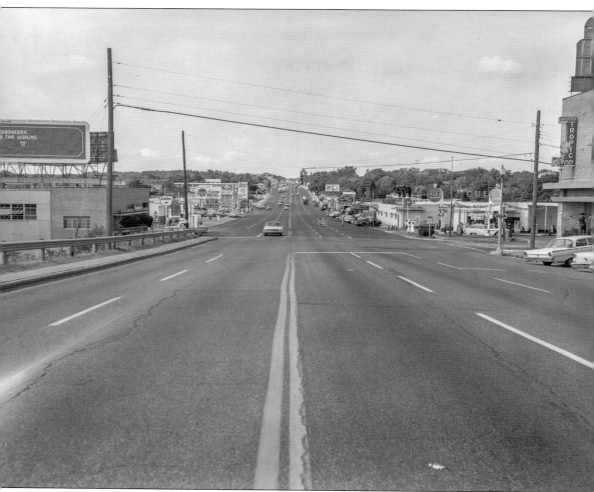

The intersection of South Congress Avenue and Barton Springs Road is pictured in 1964. A Gulf station, the Tropic Shop, the Tower restaurant, and other businesses can be seen. Most of the visible buildings have changed since then, with few exceptions. (Courtesy of the *Austin American-Statesman* and the AHC PICA 17902.)

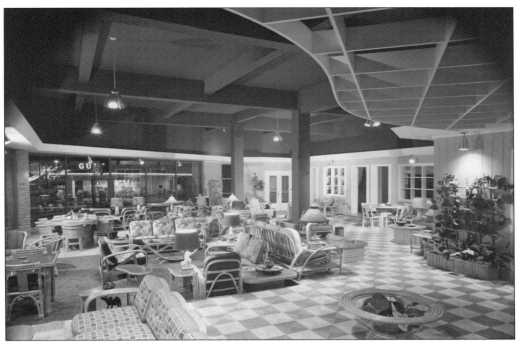

This is an interior view of the Tropic Shop in 1950. This building has also held Southwest Body Works and a warehouse in its past but had a long run with the Tropic Shop furniture. The Tropic Shop sold indoor and outdoor furniture. There was another location of the store on Manor Road. Both locations sold rattan, wrought iron, sequoia/redwood, and pine furniture in Dunbar Modern, Hastings Square, Provincial, and Early American lines. (ASPL_DM-50-C7683.)

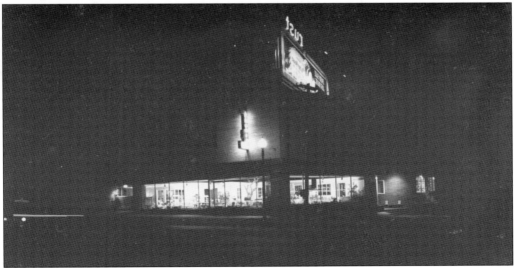

This exterior view of the Tropic Shop was photographed in 1950. This store was locally owned by the Finkelsteins, who employed professionals to assist customers with decorating plans and sales. The Finkelsteins also had a state bar exam class at one time in this location. The building itself has housed various businesses over the years and withstood the floods of the 1930s. It still stands today and is now the Yeti flagship store. (ASPL_DM-50-C7684.)

This is a 1947 exterior view of the Big Bear Food Store at 310 South Congress Avenue. It opened in 1938 and closed 20 years later. Their building is no longer standing. South Congress Avenue was rapidly developing. With the completion of the Colorado River dams, the previously flood-prone areas closest to the river were being filled in with new enterprises. Despite a flooding in 1938 and a fire in 1951, the store prospered and expanded. The Tropic Shop with the Butter Krust Bread sign is visible in the background. (ASPL_DM-47-C1353.)

This interior view of the Big Bear Food Store shows the meat counter in 1947. When it first opened, the store was a rustic open-front operation By the time this photograph was taken, however, it had grown and been remodeled into a modern grocery store—during a time when grocery stores themselves were starting to develop into larger retail operations. (ASPL_DM-47-C1354.)

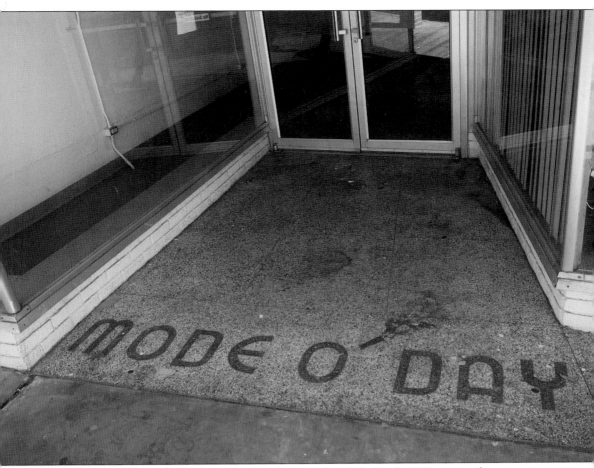

The name embedded at the entrance is the only reminder of the Mode O' Day store that was once located at the Twin Oaks Shopping Center. The former store stands empty today. Three immigrant brothers in California started this women's clothing store chain during the Great Depression. As store sites were added all over the country, the business was met with dizzying success. The owners' strategy was to make and sell their designed dresses instead of selling them wholesale to retailers. At its peak success in the mid-1960s, there were over 800 stores in 30 states. The Mode O' Day company changed names in the 1980s and no longer exists today. (Author's collection.)

Avenue Barber Shop was at 1710 South Congress Avenue. The City of Austin directories show that there has been a barbershop at this vicinity at least since the late 1920s, when David Woodland is listed as the proprietor of the barbershop and the Woodland name is carved in the top of the building. It still has the look of a barbershop from a past era. (Author's collection.)

Allens Boots, in business since 1977, is still operating at 1522 South Congress Avenue. At one time, there were more Western gear, seed and feed, and saddlery stores on South Congress Avenue, reflecting the rural culture of early south Austin. Allens Boots is one of the few remaining. Before it was Allens Boots, there was a Checker Front grocery store at this location. (Author's collection.)

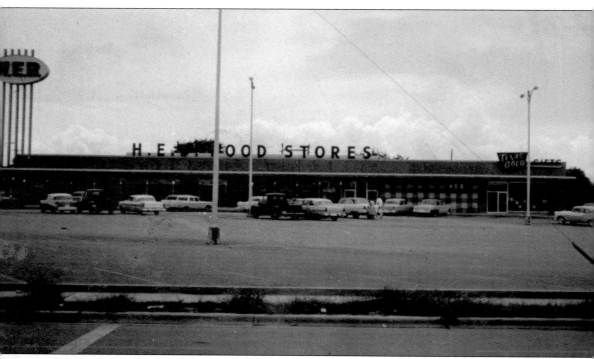

HEB has had a long history with the Travis Heights area. Since 1957, the store has been at its current location, 2400 South Congress Avenue. When it opened there, it was advertised as the largest grocery store in Austin. Previously, it had been at 2024 South Congress Avenue. Before that, it had been at 1500 South Congress Avenue starting in 1938. HEB has remained in the Travis Heights neighborhood while other area grocery stores have come and gone, including Hyden, Big Bear, Piggly Wiggly, and Safeway. (Courtesy of HEB Corporation.)

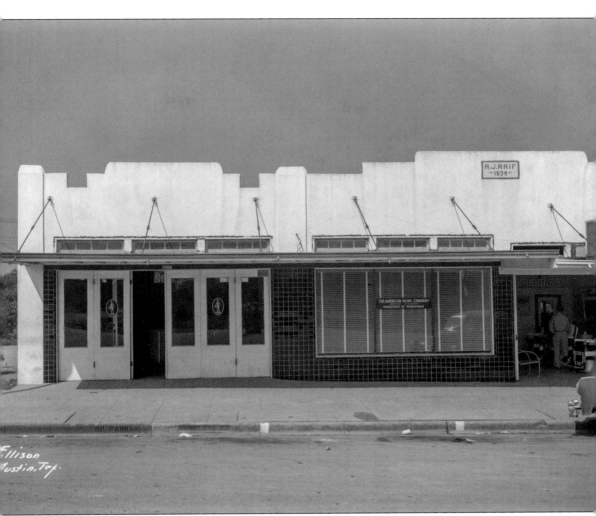

The American News Company sign on the 1700 block of South Congress Avenue is pictured in 1943. This block has also been home to businesses such as Caldwell's Variety Store, Red & White Grocery, Hirsch's TV, La Rue's Café, and Woodland Hardware. This block section in 2018 holds June's restaurant. (C05561.)

Terra Toys opened on South Congress Avenue in 1979 in part of the Woodland Building on the 1700 South Congress Avenue block. Terra Toys departed, along with the Dragonsnaps Children's clothing store, when the commercial district was rebounding and retail rental prices were escalating in the late 1990s and 2000s. Both Terra Toys and Dragonsnaps are now located in north Austin on West Anderson Lane. Their former sites are now home to Big Top Soda Fountain & Candy Store and Mi Casa Home Furnishings. (AR.1992.009 (004).)

Saunders Drugstore is pictured at 1600 South Congress Avenue in 1952. Saunders had a long run, from the late 1920s into the 1980s. Originally located in the 1200 block, it eventually moved to 1600 South Congress Avenue. Early Travis High School yearbooks have various advertisements for this drugstore. The South Congress Café is now located at that address. (C05458.)

South Austin Drug Store was located at 1208 South Congress Avenue in 1930. This drugstore is found in a 1914 *Austin American-Statesman* newspaper article listing apartments for rent on the second floor. It shows up in City of Austin directories in the 1930s but not later. Currently, the Turquoise Door shop is at this location. (PICA 15160.)

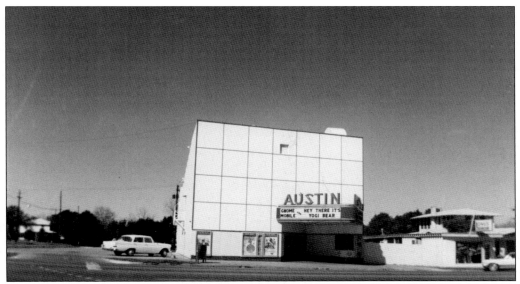

The Austin Theatre is pictured in 1966. This theater opened in 1939 on South Congress Avenue, just north of West Live Oak Street. At that time, it was near the edge of town. Some Austin residents remember going to movies there and then going to the nearby Dairy Queen or the Pig Stand restaurants afterwards. Both of those restaurants were less than a block away. As a neighborhood venue, the theater held numerous events, including weekly birthday parties with cake sponsored by McNamara Bakery. (PICA 36813.)

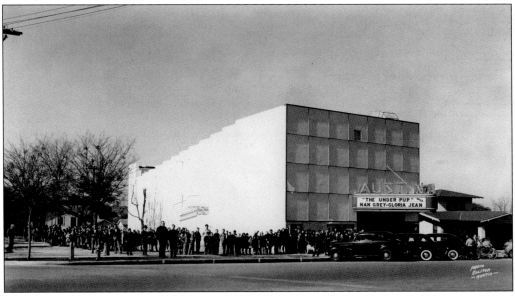

The Austin Theatre is pictured here in 1940. The best years for the Austin Theatre seem to have been before the 1970s, when it became a second-run movie theatre. By the mid-1970s, it had changed its format to showing Spanish-language films. By the late 1970s, it had become an adult theater showing X-rated movies. Finally, it closed altogether in 1998. The building has been greatly remodeled since then, but it kept the movie marquee out front and the interior staircase. Now, the former theater is home to Adlucent, a digital marketing company. (C07084.)

The Farmers Insurance Group building is pictured in 1963 alongside Interstate 35, just north of Oltorf Street. After the completion of the interstate highway, southeast Austin experienced a real estate boom with houses and large areas of apartment complexes. Businesses began to be built alongside the interstate, filling in the previously empty space until well past the city limits. The Farmers Insurance Group building is now inhabited by XO Communications. (ND-56-202B-01.)

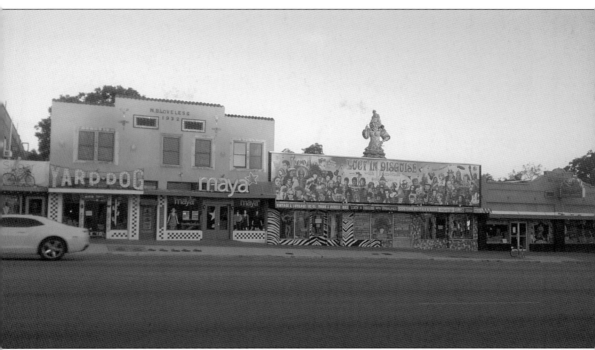

The Loveless Buildings and the 1500 block of South Congress Avenue have been the site of many businesses since the 1930s, including Checker Front grocery store, Taylors 5&10, Mulholland Jewelry, and the Piggly Wiggly that became HEB. W.B. Loveless moved to south Austin in 1895 and was one of the oldest merchants and builders in south Austin. (Author's collection.)

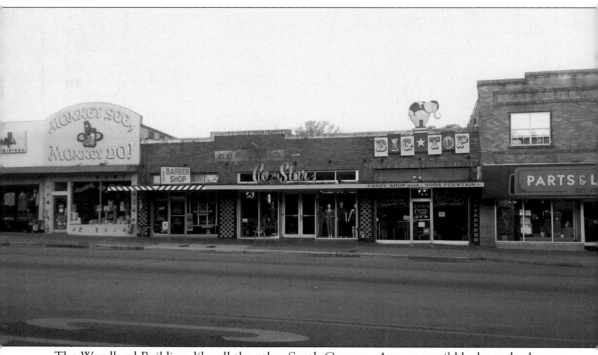

The Woodland Building, like all the other South Congress Avenue retail blocks, today houses unique and even exotic businesses that attract tourists and residents. In 1953, the retail area was considerably more focused on the needs of everyday life. For example, a "Bargain Day" advertisement ran in the *Austin American-Statesman* for Woodland Hardware at 1708 South Congress Avenue, touting the retailer as "Your Complete Hardware Store" and promising that "if we don't have it we'll get it." In 1953, David C. Woodland conceived the idea of a weekly Thursday evening shopping night where the retail stores in the 1500, 1600, 1700, and part of the 1800 blocks of South Congress Avenue held evening hours for customers to shop, with plenty of parking provided. The other area merchants adopted the idea. (Author's collection.)

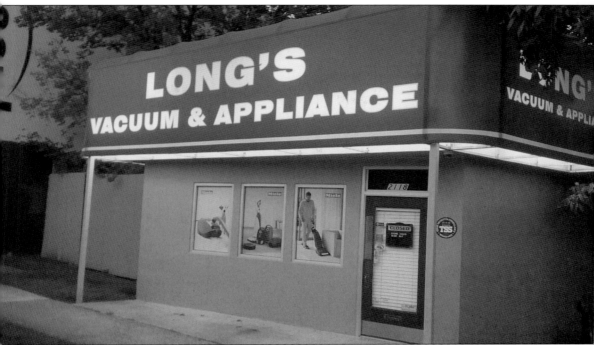

Long's Vacuum Cleaner Company has been at 2118 South Congress Avenue since 1956. It advertised in the late 1960s as primarily a vacuum store selling Hoover, Eureka, and Sunbeam brands and servicing an even greater variety of vacuums. It also completely rebuilt washing machines until the early 1990s, when washing machines began to be manufactured without internal belts and they became disposable. Just north of Long's retail store is its original homestead that was moved to this location when the company sold the two lots, on the south side, that became the site of the Austin Theatre. When the house was built in the early 1920s, that was the southern city limits boundary. This long-standing business is still in operation today, selling high-end vacuums and other appliances. (Author's collection.)

This was Sammy Allred's TV Capitol Radio & Television Shop at 2000 South Congress Avenue. Sammy Allred was well known in Austin. As part of the *Sammy and Bob Show*, Allred won CMA Awards as a radio personality in 1999 and 2006. He was also part of the Geezinslaws, a country music group. The building now houses the management company that owns the string of buildings on the west side of this block and the Magnolia restaurants in Austin. (Author's collection.)

Pictured here in an undated photograph are 1412 and 1500 South Congress Avenue. Standing alone, the 1412 building is in the middle of the photograph with the sidewalk canopy and the light pole in front. That building was initially a Poteet Seed and Feed, then Crawford's variety store, then Central Seed and Feed before it finally became Güero's Taco Bar. The next store to the left is 1500 South Congress Avenue, which has been a variety of businesses. HEB bought out the Piggly Wiggly grocery store there in 1938 and operated for a few years before moving a few blocks farther south. The 1500 building now houses Tesoros Trading Company. (PICA 35079.)

Discover Thousands of Local History Books
Featuring Millions of Vintage Images

Arcadia Publishing, the leading local history publisher in the United States, is committed to making history accessible and meaningful through publishing books that celebrate and preserve the heritage of America's people and places.

Find more books like this at
www.arcadiapublishing.com

Search for your hometown history, your old stomping grounds, and even your favorite sports team.